This is Caravaggio

Published in 2016 by
Laurence King Publishing
361–373 City Road
London EC1V 1LR
United Kingdom
T +44 20 7841 6900
F +44 20 7841 6910
enquiries@laurenceking.com
www.laurenceking.com

A catalogue record for this book is available
from the British Library.

ISBN: 978 1 78067 700 2

Series editor: Catherine Ingram

Printed in China

This is
Caravaggio

ANNABEL HOWARD
Illustrations by IKER SPOZIO

LAURENCE KING PUBLISHING

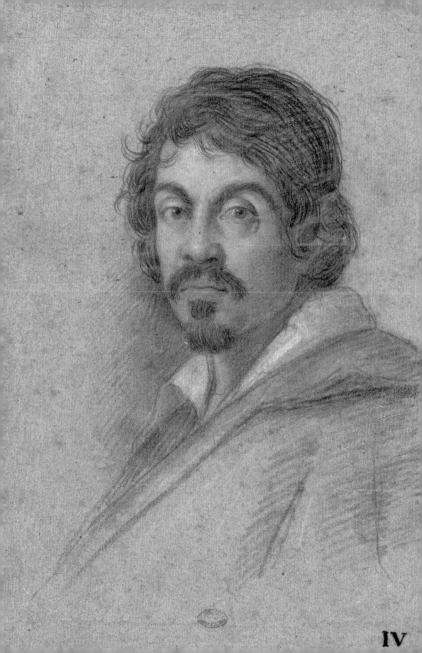

IV

Caravaggio's life is a truth stranger than fiction. His status as one of the truly seminal artists of Western art history is unquestioned. Even while he was living, collectors of his work limited access, hoping (and failing) to prevent the copyists who flocked to emulate his innovative style. Yet the man who changed the course of seventeenth-century art was no aesthete: he lived a life so full that it is amazing he found time to paint anything at all. Before his death, at the age of 39, 17 police reports had been filed against him, he'd committed murder, become a knight, and escaped from one of the world's most impregnable prisons.

Caravaggio emerged in history like a new star entering the night sky. He came from nowhere, had no ties and obeyed no imperatives but his own. His energy for life and the strength of his personality are evident from the descriptions of those who encountered him. He was short and swarthy, with penetrating black eyes under heavy brows and unruly black hair. Commentators noted with surprise that he bought only the finest materials and dressed only in black, but never replaced his clothes until they were falling apart. Sometimes his outfits were threadbare to the point that he could be mistaken for a beggar.

The angel and his demons

Michelangelo Merisi, known to history as Caravaggio, is believed to have been born on 29 September 1571 – the feast day of his namesake, the archangel Saint Michael, the champion of Heaven who had forcibly expelled Satan. At a tumultuous time for the Catholic Church, which was facing both the rise of Protestantism in the north, and the threat of the Ottoman Empire in the east, Michelangelo's naming was not without portent. One week after his birth, a Catholic fleet utterly defeated the Ottoman Turks off the coast of western Greece at Lepanto, halting the further spread of their empire across the Mediterranean, but, more symbolically, stemming the tide of Islam across the region. The entire Italian peninsula was hysterical with joy.

It seemed, initially, that the baby Michelangelo was equally blessed. But as he grew up, his nature would often prove to be more of the avenging angel – even diabolical. As an adult he could be outspoken, insensitive, condescending and vengeful. He could also be intelligent, confident and charming. Both violent and sensitive, he oscillated between action and reflection. These contradictory qualities were never resolved. Like his patron saint, he seems to have spent his life engaged in a fight between good and evil, but the devil was of his own making, and the fight completely within himself.

Caravaggio's nickname came from the country holding of his father's employer, Francesco Sforza, Marquis of Caravaggio. Merisi moved the family to the fortified medieval town when the plague struck Milan in the summer of 1576. Caravaggio was four years old. Ten thousand Milanese had died in the first two months, and the family fled just in time to avoid the travel curfew implemented in August by the city's authorities.

The Merisi owned some property in the town and would have the protection of the marquis, but tragically, by the time they settled on their three-acre plot, Caravaggio had lost his grandmother, paternal grandfather, uncle and father to the plague. The Merisi were comfortably off, but the deaths of so many meant a drastically reduced income. It is easy to imagine that these reduced circumstances in a sleepy provincial town ignited Caravaggio's desire to escape to the city. Sure enough, in 1584, aged 13, he signed a contract to start as an artist's apprentice in Milan. In a highly unusual arrangement, he paid for the privilege, which suggests that this was as much a means to establish his independence as a route to forging a career.

Wild times

That Caravaggio was not particularly dedicated to his apprenticeship is indicated by a couple of anomalies. First, there is the lack of early art by him. Not a single painting exists from the four years he spent training in Milan, or from the following four he spent carousing somewhere between Milan and Rome. Caravaggio died a celebrity, and by the end of his life people were fighting for his work. If an early piece had survived, it would certainly have been either treasured or sold.

The second piece of evidence rests in his technique. Caravaggio painted, by the standards of his time, at breakneck speed. He painted so fast he even left parts of the canvas exposed. He didn't even seem to prepare. No sketches by Caravaggio survive – implying the almost unbelievable: that he did not draw. Infrared technology has exposed no underdrawing in his paintings, only a few incisions made in wet paint to outline a cheek or a finger. It is clear that Caravaggio either learnt nothing from his Milan master, or wasn't there to learn in the first place. Either way, he himself was an anomaly. And when the first paintings do appear, they betray a clumsiness that certainly does not point to thousands of hours spent in diligent practice.

We know about Caravaggio's life from court records, police files and biographies. And two of the biographies are important. The first, from about 1620, was by a physician, Giulio Mancini, who knew Caravaggio well during the 1590s in Rome. It is short and brief, but fairly reliable. The second, longer, biography was written in 1642 by Caravaggio's rival and enemy, the painter Giovanni Baglione. Baglione is bitter, and at times he cannot resist besmirching Caravaggio's character, but his awe at Caravaggio's achievements lends him a certain objectivity, and his text has proved to be remarkably accurate. However, neither author has much to say about Caravaggio's early life, so what he was doing instead of studying is debatable. His mother died in 1590 when he was 19 and, in an act that cut all ties with his family and his past, Caravaggio sold his not insubstantial inheritance, took the cash and ran. After this, things got messy. Baglione – who would accuse Caravaggio of libel in 1603 – claims that he committed a murder that caused him to flee Milan. Another slightly later report claims that he was imprisoned for the murder and spent the money on his defence. Whichever the case, by the time he arrived in Rome two years later, aged 21, he was streetwise, tough and absolutely penniless.

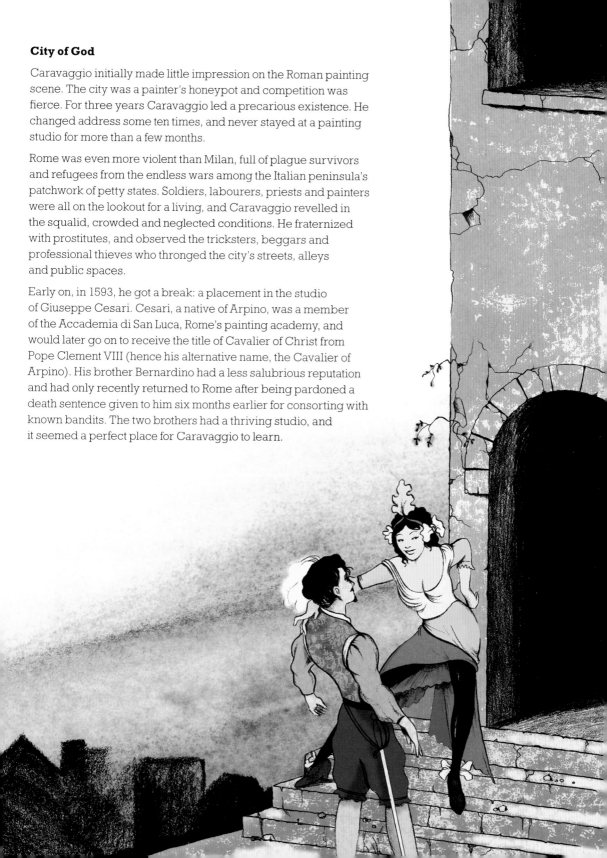

City of God

Caravaggio initially made little impression on the Roman painting scene. The city was a painter's honeypot and competition was fierce. For three years Caravaggio led a precarious existence. He changed address some ten times, and never stayed at a painting studio for more than a few months.

Rome was even more violent than Milan, full of plague survivors and refugees from the endless wars among the Italian peninsula's patchwork of petty states. Soldiers, labourers, priests and painters were all on the lookout for a living, and Caravaggio revelled in the squalid, crowded and neglected conditions. He fraternized with prostitutes, and observed the tricksters, beggars and professional thieves who thronged the city's streets, alleys and public spaces.

Early on, in 1593, he got a break: a placement in the studio of Giuseppe Cesari. Cesari, a native of Arpino, was a member of the Accademia di San Luca, Rome's painting academy, and would later go on to receive the title of Cavalier of Christ from Pope Clement VIII (hence his alternative name, the Cavalier of Arpino). His brother Bernardino had a less salubrious reputation and had only recently returned to Rome after being pardoned a death sentence given to him six months earlier for consorting with known bandits. The two brothers had a thriving studio, and it seemed a perfect place for Caravaggio to learn.

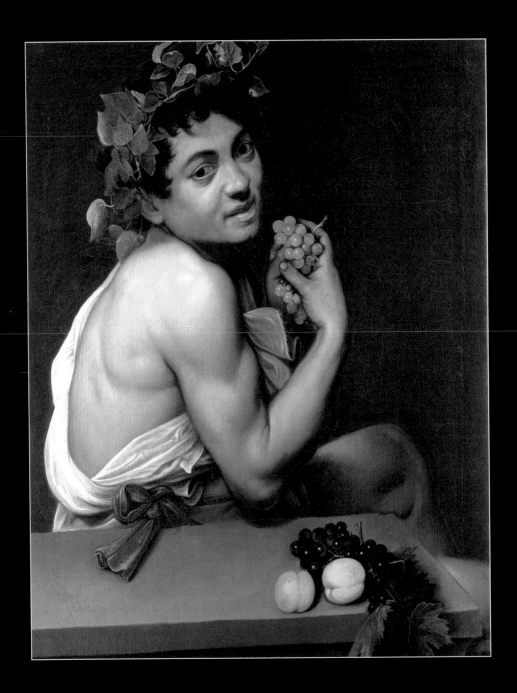

Sick Bacchus

Caravaggio, c. 1593

Oil on canvas

67 × 53 cm (26 × 21 in)

Galleria Borghese, Rome

A young iconoclast

Despite the potential of his new situation, Caravaggio's arrangements with the Cesari brothers cannot have felt like much of an improvement. On the one hand, he was exposed to a lively and successful studio, full of exciting painters and new talent. On the other, despite being the same age as the Cesari, they were at the top and he was right at the bottom of their studio ladder. His bed was a straw mat and his work – as a 'painter of flowers and fruit' – was dull, repetitive and unimportant.

At the beginning of the seventeenth century, though, Roman painting was, itself, unexciting. The rebirth of classicism that had culminated in the powerful inventions of Michelangelo had stagnated in the 40 years since his death. And the academy, conservative by nature, did nothing to help, encouraging the production of stale works reliant on old formulas – works like those produced by the Cesari brothers.

Whether driven by his competitive spirit, restless curiosity or pure boredom, Caravaggio began to experiment. The first painting by his hand is his extraordinary self-portrait as Bacchus – the *Sick Bacchus*, as it is commonly known. The most striking thing for contemporary viewers of this painting would have been how specific the facial features were. This was not a man idealized; this god was not anonymous or elegant – this is empiricism triumphant; a Bacchus who is clearly Caravaggio, the swarthy and thick-lipped Northerner, wearing a sort of cheap-imitation fancy dress.

Baglione, with not a little *schadenfreude*, claimed that Caravaggio used a mirror to paint himself because he couldn't afford to hire a model. This reads less like truth and more like an easy put-down. At best it is a partial explanation. Caravaggio, never one to suffer fools gladly, would have seen the output of the Cesari brothers as distinctly run-of-the-mill. This painting, with its unflinching realism and unflattering rendition of a classical cliché, points out the frailty of an academic standard that has fallen back on tricks of the trade and rote technicalities. Caravaggio's decision to use his own face is significant: he seems to be sending a personal message to patrons and artists alike. He is signalling change, and doing it in a deliberately provocative disguise, dressed as Bacchus, the god of disorder, passion and anarchy. The highlighted peaches in the foreground serve a double purpose. They act almost as a flourish, and 'peach' was slang for a young man's bottom; Caravaggio is mooning the art world.

Breaking from the Cesari

Caravaggio's audacity may have been built, in part, on the patronage of Costanza Colonna. Costanza was the widow of his father's former employer, the Marquis of Caravaggio, and she had known Caravaggio since his childhood. She seems to have taken a protective, maternal interest in him. By this point she had returned to the bosom of her powerful Roman family, and for the rest of Caravaggio's life, Costanza and the Colonna would set him up with contacts and come to his aid in times of trouble. Costanza never asked for anything in exchange; she never even tried to buy a painting.

Shortly after *Sick Bacchus* was painted, a mere eight months after Caravaggio arrived at the studio, his relationship with the Cesari was over. Whether the painting played a direct part in its disintegration is unknown, though certainly it is an obvious indication of the young assistant's attitude to the status quo as represented by the studio. The rupture came about after an odd incident in which Caravaggio was kicked by a horse, badly wounded by it in some fashion, and left by his masters in a corner of the studio to develop a life-threatening fever. He was discovered in this state by a Sicilian friend, who removed him to the hospital of Santa Maria della Consolazione, where he was able to recover. The Cesari brothers did not visit him and, although they kept *Sick Bacchus* and several other paintings he'd left in the studio, Caravaggio never set foot on their premises again.

It's impossible to say exactly what happened between Caravaggio and the Cesari. One explanation is that the masters were running scared and wanted to be rid of a troublesome upstart. Caravaggio's realism was, to the eyes of the time, shocking, but it was also proving spellbinding. Even in Caravaggio's early experiments, the Cesari must have seen the truthfulness and freshness of perception that would make his mature work in the next decade so great.

To add insult to injury, not only was Caravaggio a novice with little technical expertise, he was a Northerner to boot – a provincial whom they had assigned to paint lilies and apples. It must have been frightening to the Cesari to realize that whatever method Caravaggio was using, it was not one he'd learnt from them, and it was not one that any of the leading painters of the day knew anything about. In addition, it seems that Caravaggio kept his stylistic secrets well guarded.

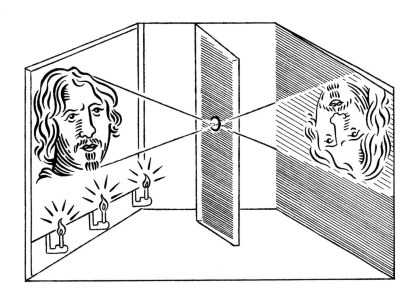

Science and magic

Caravaggio's style was described as 'natural magic' by an early admirer, but was, in all likelihood, the result of a little optical science. It had been known since antiquity that light passing through a small hole into a darkened room (a camera obscura) would cast an inverted image on the opposite wall. A century earlier Leonardo da Vinci had famously experimented with this device in his art, and it seems that Caravaggio did too. Contemporary sources mention that he always painted in 'darkened rooms', and he apparently made a 'sun light' in the ceiling of at least one of his rented rooms. The use of a camera obscura would help explain both the striking contrast between dark and light in his works (as would be produced by an image projected on to a canvas) as well as the unusually high proportion of left-handed figures in them (the result of the projection's mirror-image effect).

Caravaggio's 'natural magic' elicited either love or hate in the public, a strength of opinion that was hardly softened by his explosive personality. However, in just a few years those who loved it would overwhelm those who didn't, and the whole of Rome would be talking about what we now call his 'cinematic' technique. Institutionalized painters were right to be nervous: Caravaggio was to become the man of the hour.

Poverty and dealership

If anything, Caravaggio's breaking with the Cesari gave him the impetus to take on Rome's art market alone, without the protective umbrella of an established studio or a master.

Most of the work that survives from this period depicts young men (and very occasionally women) dressed as gods or occupied by the life of the street. The men were his friends and the props seem to have been whatever he could find. The realism Caravaggio imparted to these works is so intense it overpowers the classical symbolism, not only exposing the artifice of painting, but transforming it into something visceral, sensuous, fresh and new.

The originality of these paintings is still apparent in the *Bacchus* he made a couple of years later, in 1596 or 1597. Caravaggio is believed to have used his Sicilian friend Mario Minniti as a model – probably the same Sicilian who had taken him to hospital and helped save his life. Minniti is posed in a toga that is clearly a soiled sheet, with a wreath made from a hastily plucked vine. Whatever ambiguity exists between his divine or profane status is nowhere present in his sultry gaze as he holds a glass of heady wine out to the viewer.

With this kind of work, Caravaggio began to find a market. He even made some pieces – those that sold well – into series, painting multiple versions of the same composition. A friend from the Cesari studio, Prospero Orsi – who seems to have sacrificed what career he had to stand by Caravaggio – introduced him to a picture dealer, Constantino Spata. Spata, who was also known as Maestro Valentino, operated from a small shop he had set up in 1593. He was part of a network of dealers who sold small, cheap paintings on the open market. Many of these dealers touted their wares on the street, but Spata was lucky – his premises were near the recently completed church of San Luigi dei Francesi. Caravaggio visited the shop often and the trio became firm friends, drinking together in the local inns.

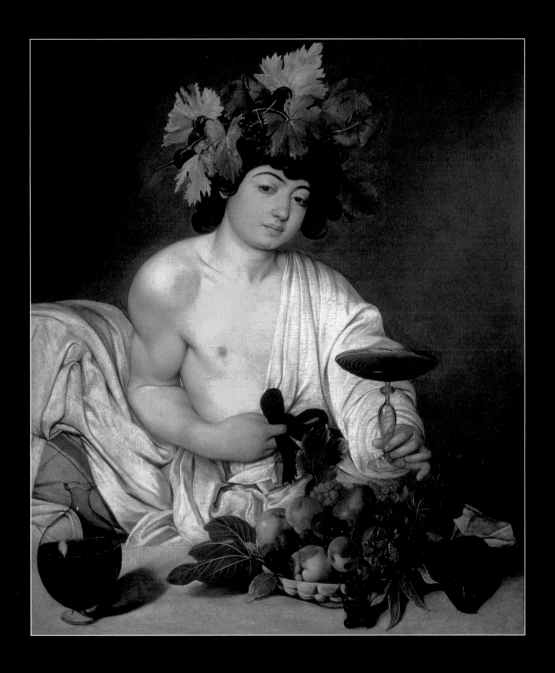

Bacchus
Caravaggio, 1596–97

Oil on canvas
95 × 85 cm (37¼ × 33½ in)
Galleria degli Uffizi, Florence

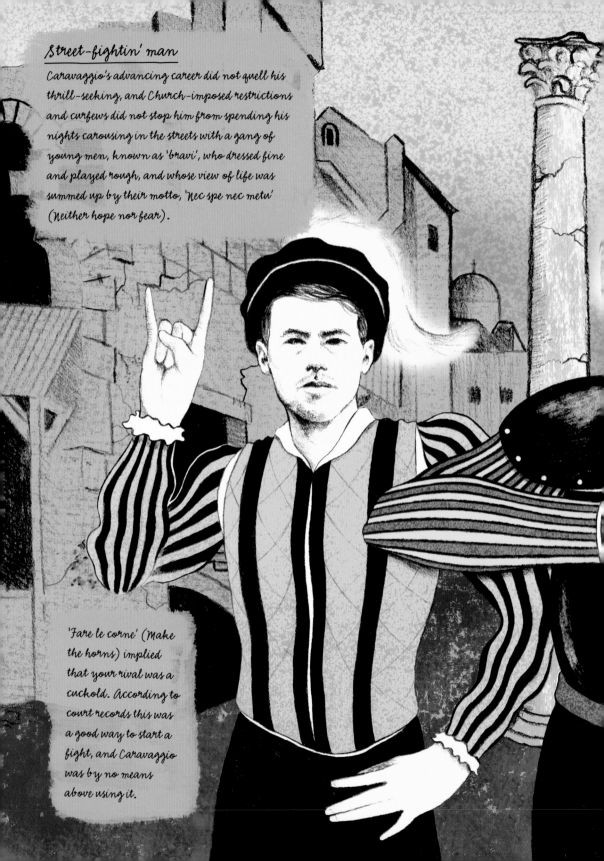

Street-fightin' man

Caravaggio's advancing career did not quell his thrill-seeking, and Church-imposed restrictions and curfews did not stop him from spending his nights carousing in the streets with a gang of young men, known as 'bravi', who dressed fine and played rough, and whose view of life was summed up by their motto, 'Nec spe nec metu' (Neither hope nor fear).

'Fare le corne' (Make the horns) implied that your rival was a cuckold. According to court records this was a good way to start a fight, and Caravaggio was by no means above using it.

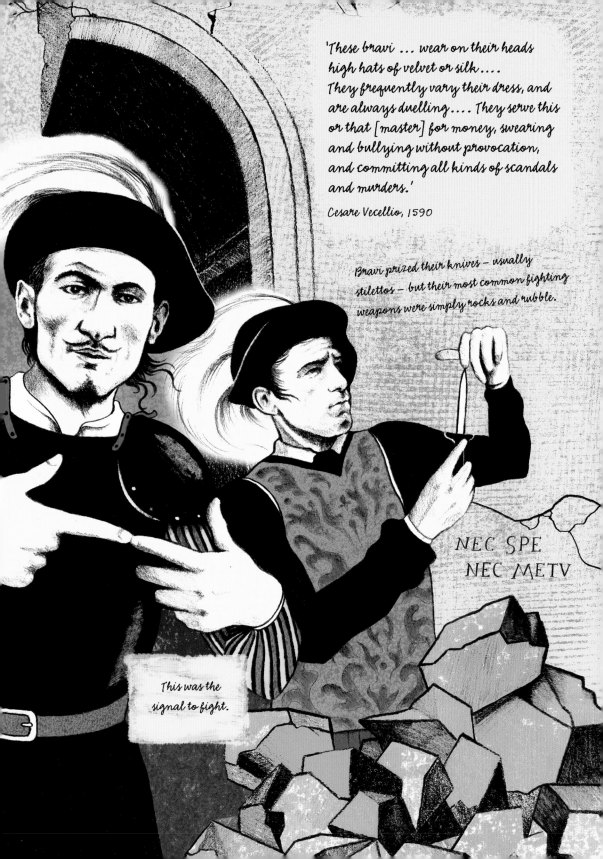

'These bravi ... wear on their heads high hats of velvet or silk They frequently vary their dress, and are always duelling They serve this or that [master] for money, swearing and bullying without provocation, and committing all kinds of scandals and murders.'

Cesare Vecellio, 1590

Bravi prized their knives – usually stilettos – but their most common fighting weapons were simply rocks and rubble.

NEC SPE
NEC METV

This was the signal to fight.

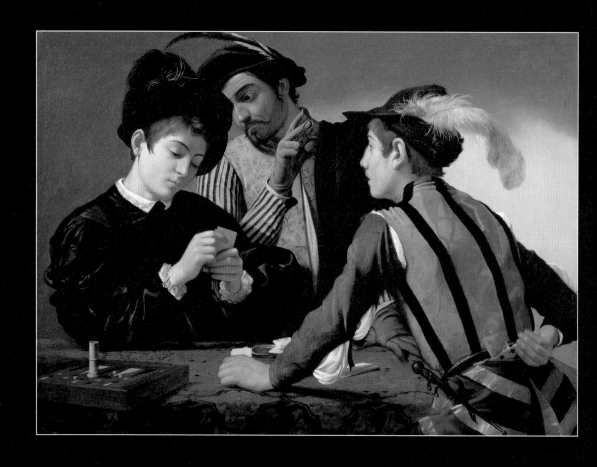

The Cardsharps
Caravaggio, c. 1594–95

Oil on canvas
94.2 × 130.9 cm (37⅛ × 51½ in)
Kimbell Art Museum, Fort Worth

Gypsies and *bravi*

The activities of Caravaggio's *bravi* acquaintances must have provided him with ample material for the more complex scenes he began to depict in the mid-1590s. He found a certain fascination, even beauty, in the bars and brothels of Rome, and his paintings from this period are often concerned with the rough and tumble of city life.

In one sense he wasn't alone – plenty of literature romanticized the gypsies who formed an important element of Roman street life, and at the turn of the seventeenth century, books and treatises on gambling abounded. What Caravaggio's images offered was a certain sensitivity to vice. His paintings of *bravi* and gypsies going about their dubious business are often funny but never moralistic. Frequently, as in *The Cardsharps*, the viewer is implicit in the misdeed – in this case, the duping of a naive young dandy who, in his innocence, does not know that the frayed ends of his companion's gloves are a tell-tale sign of a card spotter who uses his fingers to feel marked cards. This companion is also reading the innocent's cards, and using his fingers to signal their value to his partner in crime, who is pulling an extra card out of his pantaloons.

In another painting Caravaggio depicts a naive young dandy with a female gypsy fortune teller who is in the process of liberating his hand of his ring while ostensibly reading his palm. The trick here was to hold the gaze of the victim while your fingers applied subtle pressures in the process of 'reading' the lines of the palm, removing any rings on the fingers at the same time.

The novelty of the subject matter and the abandonment of a stiff academic style in these paintings coincided with a Europe-wide craze for picaresque novels, which tell colourful tales of roguish adventure. With his work, Caravaggio started a craze of his own. Although steps were taken to guard his originals, copies quickly flooded the market; 30 seventeenth-century copies of *The Cardsharps* exist, and by the 1620s many painters had built fame and fortune producing variants of Caravaggesque tavern scenes. Caravaggio had captured the zeitgeist of the period, and this breakthrough changed the trajectory of his life.

A guide to palm reading

presentation of the hand

Reading the palm

A palm well read

An influential patron

In 1595 Caravaggio's *The Cardsharps* was bought by a cardinal, Francesco Maria del Monte. Del Monte, although not as wealthy as most sixteenth-century cardinals, was a voracious collector with a curious mind. He lived in the Palazzo Madama, designed by Raphael and owned by the Florentine Medici, for whom Del Monte acted as political agent and artistic advisor. As providence would have it, the Palazzo Madama was located very near Constantino Spata's business.

Del Monte was respectfully described by his contemporaries as a philanthropist, patron and a generous, intelligent man. He was a busy and successful diplomat, but he also cultivated an interest in the arts and the humanities. His collections included sculpture, antiquities, glass, precious stones, musical instruments, ceramics, Oriental tapestries, books and, of course, paintings.

Del Monte was extraordinarily well connected. His christening in Venice was attended by his godfather, the painter and diplomat Titian – by whose hand Del Monte had no less than four paintings – as well as the poet and man of letters Pietro Aretino, and the great architect Jacopo Sansovino. His circle of acquaintances in Rome (defying the repressive doctrines

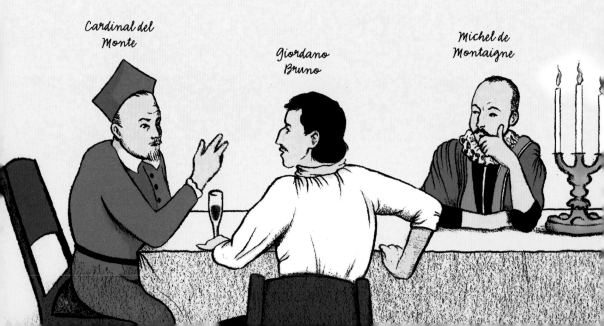

Cardinal del Monte

Giordano Bruno

Michel de Montaigne

of the Church at this time) included those who would be held at the very forefront of intellectual thought in the seventeenth century. He was friends with writers such as the popular poet Torquato Tasso, and welcomed such visitors as the French philosopher Michel de Montaigne to the city. He also supported those who were tentatively laying the foundations of modern scientific enquiry: Giambattista della Porta, whose book *Natural Magic* was one of the first to explore new theories of optics; the Dominican friar Giordano Bruno, who would be imprisoned for his belief in cosmic plurality and burned at the stake in the nearby Campo de' Fiori in 1600; and, most famously, the astronomer Galileo, who gave Del Monte a rare and precious telescope for the Palazzo Madama.

It was into this world that Caravaggio was welcomed. Del Monte did much more than buy his paintings; he gave the young painter a suite of rooms in the palazzo in which to live and work. Caravaggio's life changed. Suddenly he had stability, the confidence of a patron, and exposure to the cutting-edge thinkers of his day.

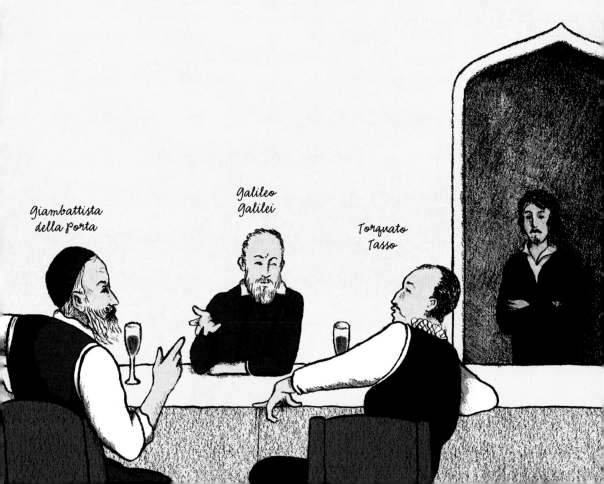

Giambattista della Porta

Galileo Galilei

Torquato Tasso

The food of love

After Caravaggio moved to the Palazzo Madama, his subject matter shifted. The cardinal played the newly fashionable 'Spanish' guitar and, by the end of his life, had amassed an impressive 37 instruments. He also ran the choir of the Sistine Chapel and had many compositions dedicated to him over the 60 years of his life in Rome. Music was becoming increasingly professionalized – an art form in its own right, rather than simply an accompaniment for religion or theatre. Del Monte was at the forefront of these changes, and he helped direct Caravaggio's attention towards music as a new subject matter. Two of Caravaggio's musical paintings were made for a wealthy friend and neighbour, Vincenzo Giustiniani, who went on to buy a total of 13 works from the artist.

The Lute Player was made in two versions – one for Del Monte, one for Giustiniani. The latter version (opposite) was made first, probably in 1595 or 1596. The boy it portrays is so feminine he is sometimes mistaken for a woman. His lips look rouged, his eyebrows stencilled and his hair artificially ornate. His shirt is slashed to reveal flesh. He is singing from a score that records, with minute accuracy but no words, portions of four madrigals by a fashionable composer. All declare love and undying devotion to their subject.

Is this painting, then, an overture to love? There is certainly eroticism in it. The boy's tongue touches his teeth, he gently strokes his thumb over the strings, a breeze stirs the score, the pears are plump, the figs have burst and a sensual light catches the silky petals of the flowers. Something in this heady mix acted as Caravaggio's new muse. Perhaps it was the boy. His unusual facial features, androgynous looks and swollen cheeks would seem to indicate he was a eunuch. This makes sense: the first castrati had recently come to Italy from Spain and one, a Pedro Montoya, lived with Del Monte from 1592.

Del Monte, as an anointed priest, was officially celibate, but his generosity towards these young men, and a famous description of a dinner at which boys dressed as women 'provided no little entertainment', have raised eyebrows. Del Monte's erudition and generosity are established beyond doubt, but it is impossible to quell speculation about whether a physical relationship might have existed between the cardinal and Caravaggio.

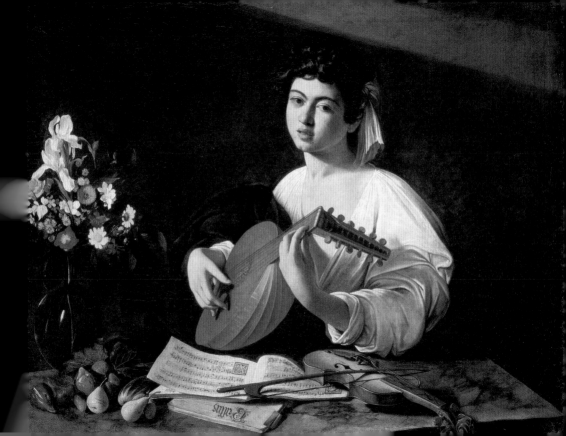

A basket of fruit

At around the same time that Caravaggio was experimenting with musical paintings, he created the famous *Basket of Fruit*. At the time, good painters didn't paint fruit – it was as simple as that. Even today, 400 years after Caravaggio embraced the idea of 'the still life', it is easy to dismiss this painting because of its subject matter. Many of Caravaggio's contemporaries did just that. Leading artists of the academy like Giuseppe Cesari found it hard to imagine why any painter would waste his time on still life, and assigned such elements of their own paintings to lowly studio assistants.

Despite having left the Cesari studio and his role there as assistant, Caravaggio had not abandoned painting still life. He didn't regard fruit as a waste of time. He also didn't paint it in a show of mere virtuosity (although that must have appealed to his performative nature). Unlike other painters, Caravaggio did not consider still life a straightforward transcription of the natural world. It was, for him, an intense examination of reality that led to a rare yet fundamental reimagining of the world. The sensitivity and intelligence he brought to it transformed peaches and grapes from simple objects to subjects in their own right. This is not ideal fruit: it is worm-eaten, overripe. Exposed as they are to a bright light, the leaves have dried out, and the grapes are coated in a fine layer of powdery mildew. To the eyes of his contemporaries, this painting would have looked more like an illustration for a science journal than a work of art.

Caravaggio's new patron, Giustiniani, understood the painter's vision. For the two of them this fruit bowl became both portrait and poem. Giustiniani even recorded one of Caravaggio's comments on the subject: 'It was as much work to make a good picture of flowers as one of figures.' Caravaggio was not only staking a claim for the value of his painting, but deliberately assaulting the view held by the academy, and the majority of artists and critics in Rome at that time, and his statement has been described as no less than a 'bomb in the piazza of Roman art theory'.

Costanza Colonna
possibly Caravaggio's
greatest protector

Cardinal Mattei
After Del Monte, an important
patron and host; he and his
brothers raised Caravaggio's
profile through commissions
for their private collection

Giovanni Baglione
A faithful defender of the academic
style, and Caravaggio's bitter enemy

Cecco di Caravaggio
Caravaggio's assistant and
probably also his lover

Cardinal del Monte
Caravaggio's first great
patron and mentor

Mario Minniti
One of Caravaggio's oldest friends
and staunchest supporters

JOKER JOKER

Ranuccio Tomassoni

Man of the street; trouble-maker, brawler and Caravaggio's deadliest enemy

The Cavalier of Arpino (aka Giuseppe Cesari)

Erstwhile employer and darling of the academy

A shuffle of acquaintances

Caravaggio had many friends, and just as many enemies. His talent attracted and repelled with equal force, and the pulse of his personality allowed him to cross the usual social boundaries of class and sex. He was loved and loathed by people from a great range of professions, genders, backgrounds and interests. Caravaggio may have been volatile, but nothing points to him being a loner.

K ♦

Q ♥

Fillide Melandroni

Courtesan, beauty, Tomassoni's lover, Caravaggio's model

J ♥

Orazio Gentileschi

Fellow painter and supporter, but also volatile and often in the midst of trouble

Alchemy

One of the most interesting and exotic strands of seventeenth-century thought was alchemy; within Del Monte's world, alchemy was part of the curious man's scientific enquiry and was seen not as magic, but as the key to the secrets of nature. Not only did Del Monte have an alchemical lab in the Palazzo Madama, but he also had a full-blown distillery at his country villa, the Casino dell'Aurora (or Villa Ludovisi), a few kilometres away near the Porta Pinciana. As a member of the Accademia degli Insensati (a loose group of European humanists), he was a minor – though not insignificant – cog in what has been described as the first 'intellectual network' in Europe. At the distillery the cardinal experimented with pharmaceutical remedies, and the most successful of these were passed around this network with both loud fanfare and debatable results.

It was for the ceiling of a small, private room at the distillery that Caravaggio was asked to paint an alchemical allegory. What he produced was, in many ways, as experimental as Del Monte's potions. First, it was painted from below, and thus demanded the kind of perspective competence that – to this point – Caravaggio had shown no signs of having. Second, it deviated from his usual subjects by depicting mythical figures – Jupiter, Neptune and Pluto. Third, it was painted straight on to the wall, eschewing Caravaggio's usual canvas, as well as most received wisdom regarding painting technique. It seems that, during this discovery of his own brilliance, Caravaggio was ready to experiment with anything – even his materials.

Old Masters

Jupiter, Neptune and Pluto made passing homage to Michelangelo's Sistine Chapel fresco (see page 40), but this was far from the only reference Caravaggio made to the giants of Renaissance art. He thrived on reimagining well-known subjects and works, and nowhere does he achieve this more dramatically than with his *Medusa*.

Competition was implicit in the *Medusa* from its very conception. Del Monte had commissioned it specifically for his Medici patrons, intending it as a diplomatic jest and a compliment, a specific piece of flattery that would surpass typical diplomatic gift giving and help him curry Medici favour. The joke hinged on a famous piece from the Medici collection: a shield painted by Leonardo da Vinci. Stories circulated that the shield, which depicted Medusa emerging from the rocks, was so terrifying that it could turn a man to stone (as Medusa herself could). The shield had, however, been missing since at least 1596 – and some have speculated whether it existed at all.

Whether the painting ever existed or not, the reference to Leonardo in Del Monte and Caravaggio's visual joke would have been obvious to its intended viewers. He even painted his Medusa on a canvas stretched over a tournament shield. But Caravaggio, of course, went one step beyond Leonardo's composition. He does away with landscape and focuses instead on the decapitated head which, apparently still living, is as shocked as we are by her bloody demise. Her hair – a nest of snakes meticulously observed from nature – continues to writhe. She is, like us, conscious of her own mortality.

This is a brutal image, dramatic almost to the point of melodrama. It is, of course, a meditation on mortality. It is also a meditation on consciousness and a challenge to artists past and present. Caravaggio knew how to shock, but that was never the end goal of his work; however visually arresting, something always lingers beyond the surface.

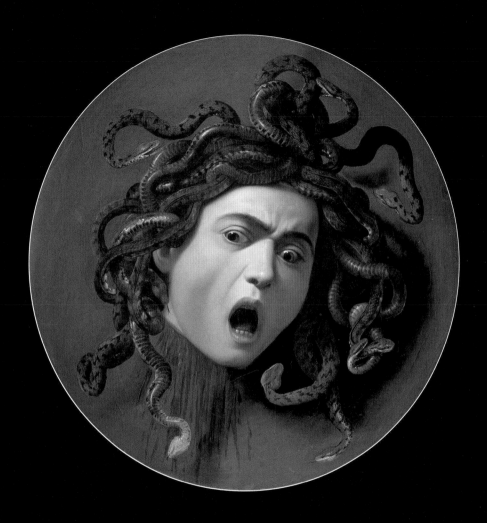

Medusa

Caravaggio, 1597

Oil on canvas mounted on wood
60 × 55 cm (24 × 22 in)
Galleria degli Uffizi, Florence

Strife in the eternal city

When Caravaggio moved into the Palazzo Madama in 1595, Rome was already gearing up for the Jubilee of 1600. Within the Church calendar, a Jubilee was a special year of universal pardon, and during this particular one, Rome – which at this time had a permanent population of less than 100,000 – would be flooded by over three million pilgrims seeking redemption from purgatory by visiting the many holy sites around the city.

Pope Clement VIII, from the moment of his election in 1592, had set out with zeal to clean up the city of all those things that Caravaggio would have found most attractive. He corralled a veritable tidal flow of 'official' prostitutes into a small quarter by the river, which quickly became nicknamed 'the Garden of Evil' – a pun on the 'Garden of Eden' into which Clement hoped to transform the city. He also passed various laws to curb violence, such as banning the possession of weapons and outlawing duels. Those who fell foul of the law were made into examples. At public executions, priests exhorted the crowd to take heed and learn from the sins of others.

The most high-profile trial of this period was that of the Cenci family. On 9 September 1598, the corrupt and violent Count Francesco Cenci was found dead on a rubbish dump outside his castle, northeast of Rome. According to rumour, Beatrice, his daughter from his first marriage, and his second wife, Lucrezia, had been suffering abuse at his hands for years. The blame for his suspicious death quickly fell on their shoulders. Beatrice – young, beautiful and composed – refused to confess, even under torture. She became a *cause célèbre* in a case that gripped Rome but, after a year-long trial, she was sentenced to execution for patricide, along with her stepmother and older brother, Giacomo. Beatrice was decapitated alongside Lucrezia, but Giacomo had bits of flesh torn from his body with red-hot pliers before receiving a fatal blow to the head with a mallet. His body was then cut into quarters. In this, the pope had gone too far. Public opinion turned, and talk was countered with another new law: libel became an offence.

Despite – or perhaps because of – all these new regulations, Caravaggio was ever more attracted to the rough and tumble of the street, and continued in his disregard of the law. In the court record of 1598 he is cited as having been caught carrying a sword after 11 in the evening. It was not to be the last time.

Violent nature, violent art

Over a third of Caravaggio's paintings depict some violent subject, with decapitation being a clear favourite. However, it is worth remembering that, with the exception of the *Medusa*, all of these were of a religious nature. Painters of the period were encouraged to depict martyrs in the throes of violent death, and even to observe executions so as to render the gestures of condemned men more accurately. In this context, the violence of Caravaggio's work becomes less surprising. But what made his images of violence and passion so convincing was his self-conscious particularization of detail, and his carefully chosen exaggerations of light and motion. He had a gift for action painting and, when he applied his exuberant naturalism to it, he created art with all the drama and life of a modern film-maker's work.

Some found – and still find – his solutions extreme. A more classicizing seventeenth-century artist, Annibale Carracci, described Caravaggio's *Judith Beheading Holofernes* as 'too natural'. As with the earlier *Medusa*, some critics found the painting's decapitated head too frighteningly lifelike and – with the arterial blood gushing from the neck – too dreadfully and undoubtedly alive.

Some took offence not just at the style but also at other details: Judith's erect nipples and her obvious similarity to Fillide Melandroni, a local prostitute from the Piazza Navona. But younger artists like Artemisia Gentileschi would later be immediately convinced of his genius and inspired by it. Caravaggio, as he had done since his earliest years, divided opinion.

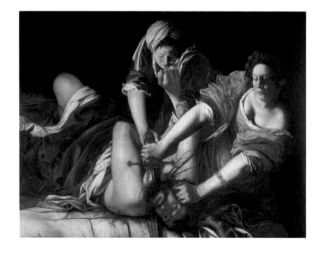

Artemisia Gentileschi
Judith and Holofernes,
c. 1614–20 (detail)

Oil on canvas
199 × 162 cm (78³⁄₈ × 63¾ in)
Galleria degli Uffizi, Florence

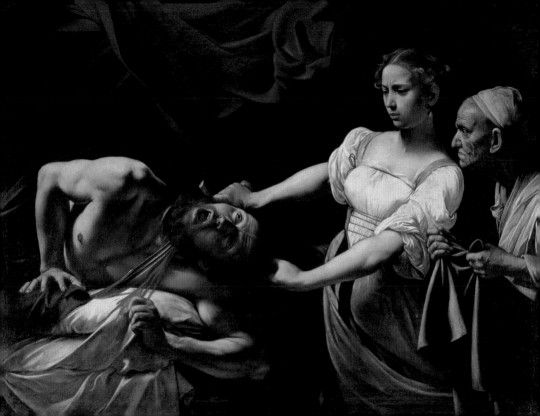

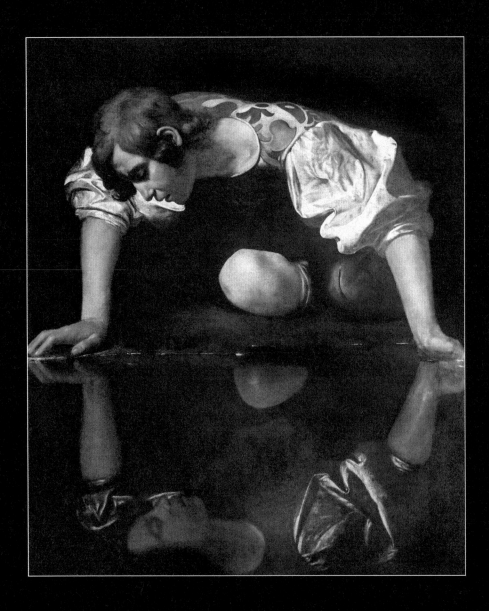

Narcissus
Caravaggio, c. 1597–99

Oil on canvas
110 × 92 cm (43 × 36 in)
Galleria Nazionale d'Arte Antica,
Palazzo Barberini, Rome

On reflection

The violence and swagger of the *Medusa* and *Judith Beheading Holofernes* are absent from the much more meditative *Narcissus* of the same period. Over the course of his career, Caravaggio appeared in his own compositions no fewer than eight times. That is one reason why his painting of Narcissus is so fascinating. In Ovid's *Metamorphoses*, Narcissus is a young man who one day sees his reflection in a pool of water and falls in love with it. Entranced by his own beauty, he loses perspective on reality and fades away to death.

Narcissus represented the dangers of the self, but also implied the dangers of losing touch with reality. Perhaps Caravaggio conflated the two – his whole career explored the relationship between representation and reality. In *Narcissus* he meditates on the danger of believing reflections. Narcissus leans over the pool, forgetting that the reflective surface is, in fact, nothing more than water. Perhaps the painting was meant to act as a reminder to Caravaggio himself not to always believe or trust the man in the mirror.

Certainly the arrogance Caravaggio displayed towards his fellow painters around this time did not reflect the reality of his situation – by 1599 he still had not garnered a public commission. Luckily for him, a situation was brewing in the church of San Luigi dei Francesi, just around the corner from Spata's shop and the Palazzo Madama.

Breakthrough

In 1599 the priests at San Luigi were in a panic. Almost 35 years earlier a French cardinal, Matteo Contarelli (Mathieu Cointrel), had paid a small fortune for a funerary chapel in the church. With the Jubilee approaching fast, they were desperate to complete the chapel's decoration, which had been beset with delays.

Del Monte put Caravaggio forward and the priests – cornered by the influential cardinal – gambled a big commission on an untried name. In exchange for two canvases of around 3 by 3 metres (10 by 10 feet) each, they paid 200 scudi. It wasn't an enormous sum but, put in perspective, Del Monte had paid 8 for *The Cardsharps*. If Caravaggio lived up to expectation he could expect more and better commissions. If not, he'd probably paint genre scenes for the rest of his life. The stakes were high.

The painting to the left of the altar was to depict Contarelli's namesake – Saint Matthew – being summoned from his life as a tax collector by Christ. Caravaggio painted this scene with the same level of empiricism and naturalistic detail as his smaller, private works. The setting is clearly a contemporary Roman tavern – dingy, dark and inhabited by a motley crew of tricksters and *bravi*. Christ enters from the right, his fine halo barely illuminated by the shaft of light that brightens Matthew's confused face and lights his hand. 'Is it really me?' he asks. Here, Caravaggio has combined his genre painting of street life with a biblical subject. He has made Christ accessible.

With typical ambition and confidence, Caravaggio also inserted a reference to one of Rome's most recognizable works: Michelangelo's *Creation of Adam*. The Christ figure points at Matthew with the same languid, magnificent gesture as God uses at the centre of Michelangelo's ceiling, reaching out to give life to Adam.

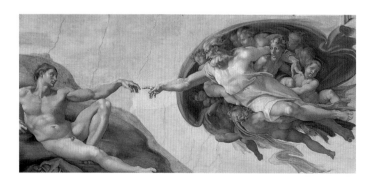

Michelangelo Buonarroti
The Creation of Adam,
c. 1512 (detail)

Fresco
280 × 570 cm (108 × 170 in)
Sistine Chapel, Vatican, Rome

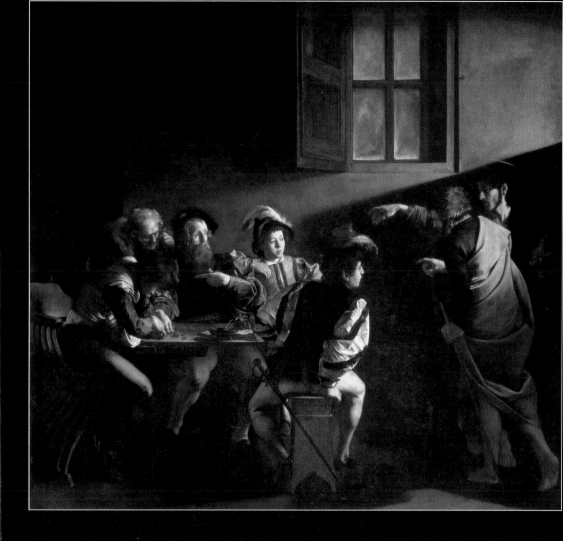

The Calling of Saint Matthew

Caravaggio, 1599–1600

Oil on canvas

322 × 340 cm (126¼ × 133⅞ in)

San Luigi dei Francesi, Rome

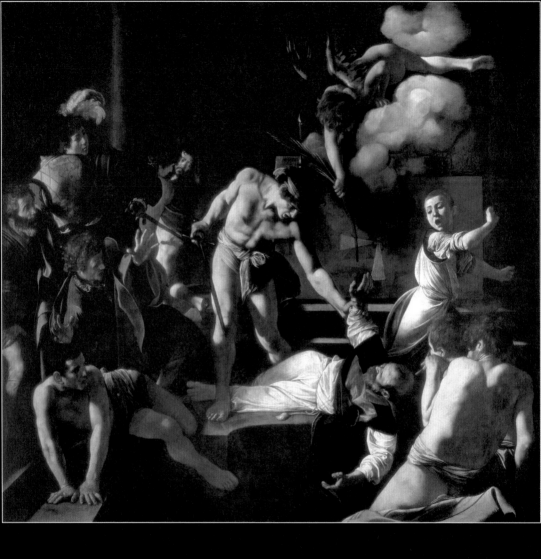

The Martyrdom of Saint Matthew

Caravaggio, c. 1600

Oil on canvas

323 × 343 cm (127 × 135 in)

San Luigi dei Francesi, Rome

Triumph

Caravaggio struggled with the second painting for the chapel. He painted *The Martyrdom of Saint Matthew* – complex and full of figures – twice before he was satisfied. In the end he produced something no one expected, either from an altarpiece or from a scene of martyrdom.

Matthew does not make a glorified ascent to the celestial realm but dies vulnerable, alone and unaided on the brutal, dark streets of Rome. There is nothing ethereal – even the angel struggles to balance on a sculptural cloud while offering an unseen palm of victory to the desperate saint.

As well as human suffering, Caravaggio offers his viewer drama. Because the chapel is perpendicular to the aisle of the church, all the approaching viewer sees is the soundless scream of the child fleeing the scene of the execution. Caravaggio knows how to hook his audience. Following the child's gaze, the viewer focuses on the central scene, so intense it has flung all the other figures to the periphery. One of those figures, bearded, illuminated and in the far background, mirrors the viewer's own reaction. He is, like us, slightly outside the circle. His gaze is curious and somewhat wistful, but he is passive, he makes no move to intervene. He is, in fact, the scene's witness. He is Caravaggio.

The reaction to both paintings in Rome was electric, and news of them spread like wildfire. But reactions were not uniformly positive. Unsurprisingly, a notable criticism came from the president of the Accademia di San Luca, Federico Zuccaro. The paintings were 'too natural', he said; they lacked imagination. He dismissed the work, declaring that he couldn't see what all the fuss was about.

Regardless of the academy, Caravaggio's star was on the rise. Del Monte, who could not afford the painter's higher prices, encouraged him to move to the nearby Palazzo Mattei, home of the erudite, wealthy and pious Cardinal Girolamo Mattei and his art-collecting brothers Ciriaco and Asdrubale. The Mattei were crucial to the next stage of Caravaggio's career – not only in buying his work, but also in building his reputation. Del Monte, however, remained a pillar in Caravaggio's world, stepping in to bail him out of trouble with the police in 1604, and buying a knock-off copy by Caravaggio of one of his later, more expensive, paintings.

The honour code

Zuccaro may have dismissed the Contarelli Chapel, but the rest of Rome took notice. The result was prestige and public commissions. Shortly after the Saint Matthew panels were installed, Caravaggio was contracted for two paintings to decorate Tiberio Cerasi's chapel in the Santa Maria del Popolo, a major church on the pilgrimage route.

The subjects were to be Saints Peter and Paul, foundation of the Roman Church. Saint Peter is depicted at his martyrdom, old and afraid, being hoisted upside down on to a cross by three straining labourers. The only nods to traditional iconography are Peter's position (he asked to be crucified upside down so as not to die in the same manner as Christ) and the foreground colours (the saint was traditionally recognized by his blue and yellow robes). The finished work was another triumph.

Caravaggio may have been producing masterpieces, but his private life did not settle. In the autumn of 1600 he engaged in a sword fight with a mercenary whom he outfought and wounded. The man proceeded to prosecute, but the case was settled out of court, almost certainly with a pay-off. However, no such resolution was met in November of that same year, after Caravaggio attacked a young painter named Girolamo Spampa. Spampa was walking home from the academy one night when Caravaggio, who'd been lying in wait, attacked him from behind. Spampa felt lucky to escape with his life.

Caravaggio had a hot temper, but his aggression was far from anomalous in the Rome of his day. Many men were driven to violence by a complex honour code that dictated an eye for an eye on matters of reputation, or *fama*. A typical example was the *sfregio*, or face slash, which was meted out in response to severe disrespect or humiliation. Spampa, a devout academician, may have been repeating his president Zuccaro's views on Caravaggio's work. In Caravaggio's mind, a literal stab in the back was just payback in kind.

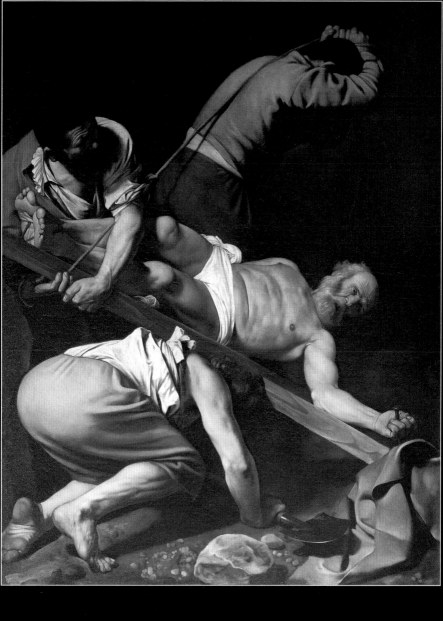

The Crucifixion of Saint Peter

Caravaggio, c. 1601

Oil on canvas
230 × 175 cm (90½ × 69 in)
Santa Maria del Popolo, Rome

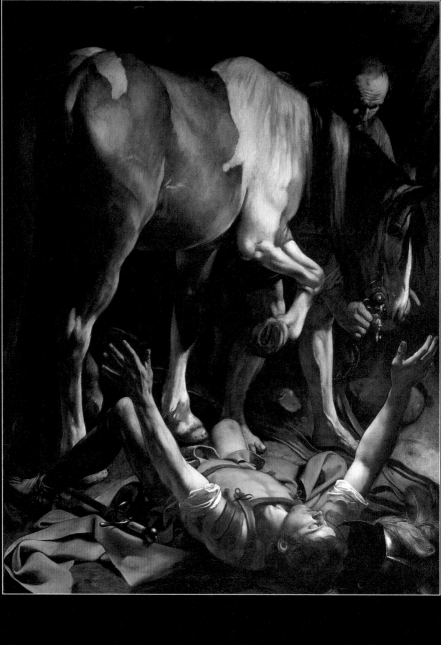

The Conversion on the Way to Damascus
Caravaggio, 1601

A showdown of styles

Tiberio Cerasi wanted the finest money could buy. He risked Caravaggio's rising star, but for the chapel's altarpiece he also employed a stalwart of the academy, Annibale Carracci – the painter who'd criticized Caravaggio's *Judith Beheading Holofernes* for being 'too natural'. The stage was set for a showdown.

Although his work was eventually a success, the Cerasi Chapel paintings were not easy for Caravaggio. Either his inexperience with such large commissions, or the strain of besting Carracci, resulted in the rejection of his first attempts. Forced to reconsider, Caravaggio fell back on his strengths: condensed narrative, mysterious darkness and raking light. Nowhere are they more successfully employed than in the painting of Saint Paul's conversion on the road to Damascus. Saul, a Roman solider and persecutor of Christians, is blinded by a great light and falls from his horse. As he lies stricken he hears the voice of God. He renounces his past and takes a new name: Paul.

Caravaggio's solution is evocative and poetic. It is as easy for the viewer to believe Saul's religious ecstasy as to recognize the obliviousness of the servant, attending to the ponderous horse as it recovers from its recent spook. The composition is elegant and simple. It also allowed Caravaggio room for a little ribald humour: contemporary viewers did not fail to notice that the horse's bottom was pointed directly at Carracci's painting, which hung above the altar between Caravaggio's two canvases.

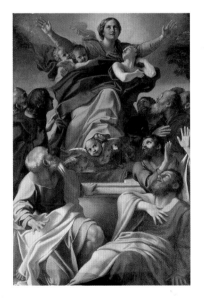

Annibale Carracci
The Assumption of the Virgin, 1600–1601
(detail)

Oil on canvas
245 × 155 cm (96 × 61 in)
Santa Maria del Popolo, Rome

The sword of sex

Caravaggio has been described as 'swinging the sword' of sex in his art. If this is true for any painting, it is true for *Amor Vincit Omnia* ('Love Conquers All', often referred to in English as *Victorious Love*), a private work made in 1602. In it a young boy slides off an unmade bed, oblivious to the symbols of culture, knowledge and ambition that lie in a casual heap on the floor behind him. This is no idealized youth in the tradition of Michelangelo; he is cheeky, risqué and entirely real, complete with hand-made wings and a hot flush. Even the worldly Giustiniani, for whom the painting was made, kept this work hidden behind a velvet curtain.

This painting is the source of several clues about Caravaggio's own sexuality. The English traveller Richard Symonds, who saw the painting in situ shortly after it was completed, described the subject as Caravaggio's 'owne boy or servant that laid with him'. This nonchalant aside, which implies not only that Caravaggio was homosexual but that this was more or less common knowledge, is backed up by the 1605 census, which records him living with a boy named Francesco. This is almost certainly Caravaggio's assistant (nicknamed Cecco), who was the model for this painting.

It is hard to gauge Caravaggio's intent, as his art so often tests the line between realism and parody, especially with images of the body and allusions to sex. In his youth in Milan, the superstar of the city's painting scene had been Giuseppe Arcimboldo – famous for his moral allegories of faces and figures composed of inanimate objects such as fruit and vegetables. Using the same conceit, Caravaggio would instead make a ribald sexual pun in his *Still Life with Fruit on a Stone Ledge*.

With *Victorious Love*, however, he played with fire. In the space of a few short weeks Caravaggio was, himself, the subject of public parody. Not a man to laugh lightly at himself, Caravaggio took his revenge, leading to his first really serious run-in with the law.

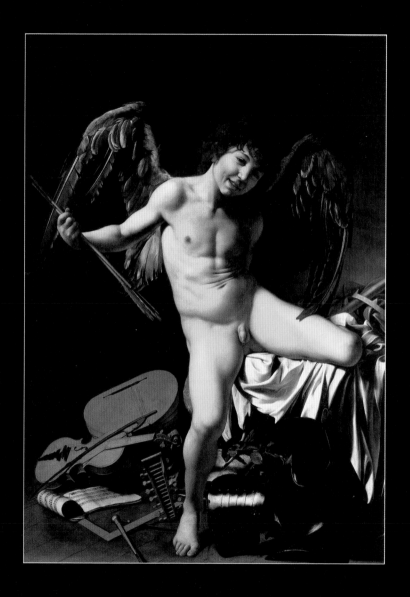

Victorious Love (Amor Vincit Omnia)
Caravaggio, c. 1602

Oil on canvas
156 × 113 cm (61 × 44 in)
Gemäldegalerie, Staatliche Museen zu Berlin

Libel

Even though *Victorious Love* was secreted behind a curtain in Giustiniani's collection, its fame spread quickly around Rome. In response, Baglione – Caravaggio's rival and future biographer – produced a painting called *Sacred Love and Profane Love*, which was displayed at the Accademia di San Luca on 29 August 1602. It depicts a brightly lit angel trampling over two prone males. One – older and swarthier – has quickly turned away, as if in shame. The other – younger, rather beautiful, and naked except for a girdle – swoons. He bears an uncanny resemblance to Cecco.

The success of the painting was such that Baglione produced a second. In it, the older man's head is turned out, and is clearly a demonized portrait of Caravaggio. It was bought by none other than Giustiniani's brother, for his rival collection. Caravaggio's humiliation was complete.

Caravaggio was vengeful but he was not rash – at least not on this occasion. He waited seven months for the grand unveiling of one of Baglione's most prestigious commissions before anonymously posting defamatory poems around Rome. Defamation was a capital offence, but it didn't stop Caravaggio referring to Baglione as a 'fucked-over cuckold' and rhyming his name with *coglione*, or testicles (slang for 'fool'). For good measure, he also attacked Baglione's friend Mao Salini, telling Baglione to stuff his drawings 'up the cunt of Mao's wife/Because he is not fucking her anymore'. Charming.

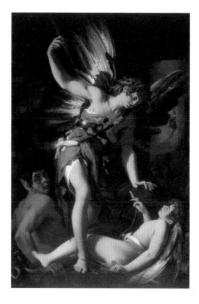

Giovanni Baglione
Sacred Love and Profane Love, 1602

Oil on canvas
240 × 143 cm (94½ × 56¼ in)
Galleria Nazionale d'Arte Antica,
Palazzo Barberini, Rome

Escape to Loreto

On 11 September 1603 Caravaggio and his friends found themselves in prison, facing very serious charges over the Baglione escapade under the new libel law. The prospect of a lengthy jail term did not prevent Caravaggio from being a taciturn and difficult witness. He was forthcoming on just one point: the ineptitude and ignorance of Baglione, declaring 'I don't know any painter who thinks … [he] is a good painter'. The case went badly until, in late September, Caravaggio and his friends were mysteriously released under bail. It was a lucky escape – someone rich and powerful had clearly intervened.

Caravaggio could push his luck only so far, however. After the trial he left town. Officially, he made a pilgrimage to Loreto, on the east coast of central Italy, and the unlikely location of the Holy House of the Virgin Mary, reputedly carried there by angels at some point during the Crusades of the eleventh to thirteenth centuries. The Madonna of Loreto was the subject of Caravaggio's next altarpiece, and his 'research' provided the excuse he needed for a break from the heat in Rome.

When he returned a whole year later he created one of his quietest and most moving works. The barefoot Virgin appears on her threshold before two weary pilgrims who kneel in prayer – as the viewer of this altarpiece would have done. At exactly the kneeling viewer's eye level are their filthy feet. Feet did not sit well with ecclesiastical patronage. Caravaggio had already had two altarpieces rejected because of indecorous foot exposure. Perhaps he hadn't learnt his lesson; perhaps he just wanted to make a point. In post-Jubilee Rome, the Church was subtly turning its attention away from poverty. Caravaggio, however, was surrounded by it, as were the many people who'd see this painting, and in it Caravaggio awards the poor a privileged role. It is the man with the dirty feet whose hands rest a hair's breadth away from the Christ child's toe. Most shocking was the Madonna: not only poor, but clearly recognizable as a local prostitute, Lena, who was described by a friend and biographer of Caravaggio as 'a courtesan whom he loved'.

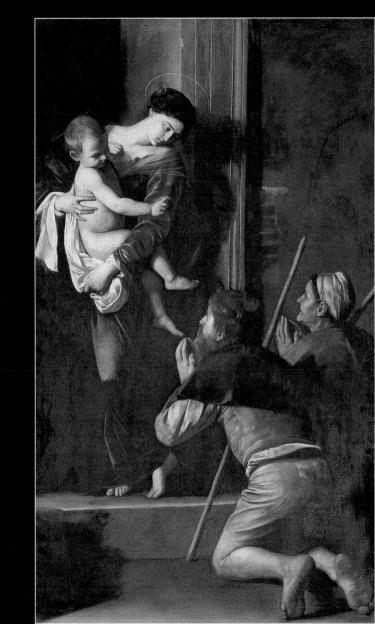

A spiralling temper

Caravaggio returned to Rome feisty and ready for a fight. In April 1604 he was in one of his favourite inns, the Osteria del Moro, when what should have been a minor dispute with a waiter over some artichokes he had brought to the table ended with Caravaggio snatching up the plate and attacking the waiter with it. The wounded waiter took the case straight to the authorities, but Caravaggio was again let off; it seems that Cardinal del Monte stepped in. When Caravaggio was arrested in October – this time for throwing stones at some policemen – the painter asked a friend to visit the cardinal on his behalf. That night, in prison, he bragged that he would be free the next day. And he was. A month later, though, he was imprisoned again – this time for insulting an officer.

These run-ins with the authorities hint that Caravaggio was involved in something more than mere youthful high jinks. And although his violent outbursts reflected the honour code of his world, they occurred too frequently to be a mere symptom of the times. In the summer of 1605 he was back in court like a bad penny: imprisoned for defacing doors, throwing rocks at his

ex-landlady's house, and committing grievous bodily harm against a notary in a fight over a woman called Lena – quite possibly the Lena he'd painted as the Virgin Mary.

Alongside or parallel to Caravaggio's name, a number of others pop up time and again in the court records: the prostitutes Lena and Fillide, and a number of Caravaggio's faithful but trouble-loving friends. There were also rivals, notably Ranuccio Tomassoni. It has been suggested that Caravaggio and Tomassoni were low-grade pimps, engaged in a struggle for power. But their rivalry may also have been a simple, old-fashioned love feud. Fillide, who became Caravaggio's favourite model, was Tomassoni's lover as well as a working girl. We know that she was committed to Tomassoni (at least for a time) because, in 1600, she attacked a woman she found in bed with him, threatening to disfigure her with a knife. Lover or whore, Fillide was at the centre of a brewing crisis, and it erupted in the summer of 1606.

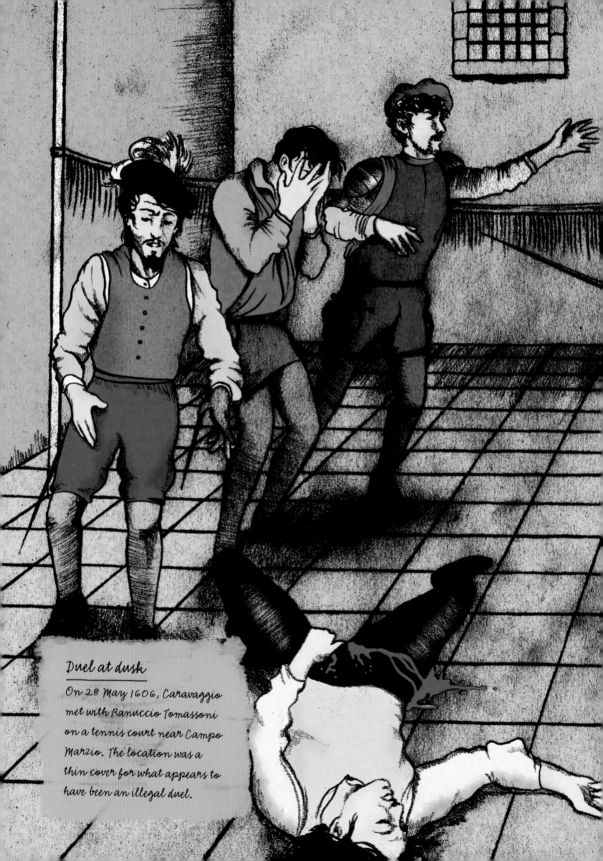

Duel at dusk

On 28 May 1606, Caravaggio met with Ranuccio Tomassoni on a tennis court near Campo Marzio. The location was a thin cover for what appears to have been an illegal duel.

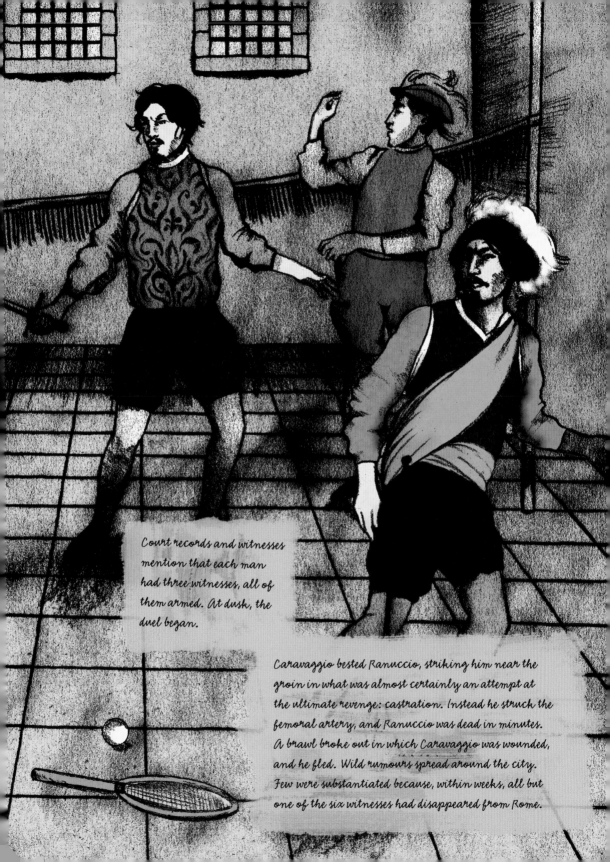

Court records and witnesses mention that each man had three witnesses, all of them armed. At dusk, the duel began.

Caravaggio bested Ranuccio, striking him near the groin in what was almost certainly an attempt at the ultimate revenge: castration. Instead he struck the femoral artery, and Ranuccio was dead in minutes. A brawl broke out in which Caravaggio was wounded, and he fled. Wild rumours spread around the city. Few were substantiated because, within weeks, all but one of the six witnesses had disappeared from Rome.

Departure

Caravaggio had committed the ultimate sin: murder. No amount of aristocratic arm twisting could help him now. He was subject to a 'capital sentence', making it legal for any person within the Papal States (which spread from coast to coast, covering a good quarter of the Italian peninsula) to kill him with impunity.

Caravaggio had to escape Rome and the Papal States, and he had to do it fast. Someone must have helped him – someone with connections and money for bribes, and willing to put a lot on the line for nothing in return. This was most likely his oldest protector: Costanza Colonna.

Caravaggio left with just a few painting tools, and probably his dog, the only creature in his life not in a position to judge. He even left behind his unsold masterpiece, *The Death of the Virgin*. In it the Virgin – whose slightly bloated corpse is pallid and whose legs are already stiff with rigor mortis – has, in her death, reduced her loved ones to a silent, private grief. This desperate, weighty painting was rejected by the church it had been commissioned for (Santa Maria della Scala), and it was abused by others for portraying the Virgin 'like some filthy whore from the slums'. Caravaggio had transgressed boundaries before, but this case was extreme: the Virgin was probably drawn from a dead prostitute, drowned in the Tiber, and her face is that of the prostitute Lena who had modelled for his earlier painting of the Virgin. Added to this was the fact that the painter was a murderer on the run.

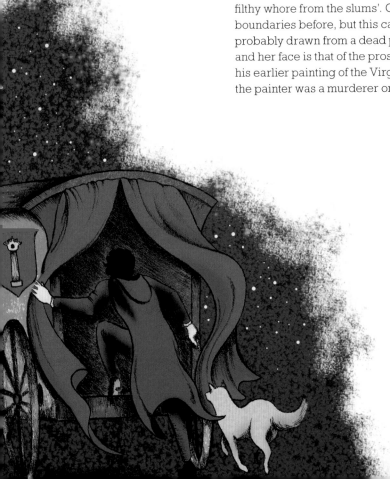

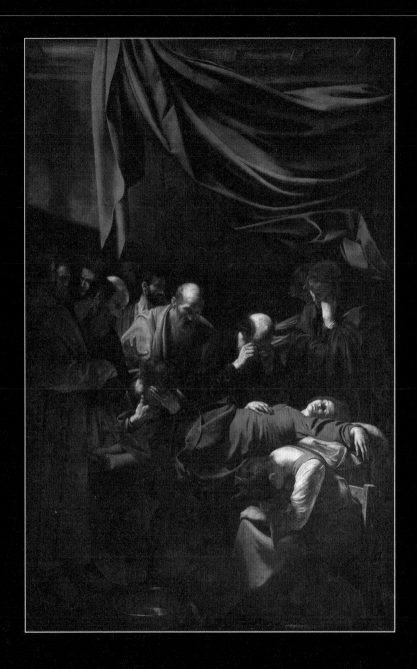

The Death of the Virgin
Caravaggio, c. 1605–6

Oil on canvas
369 × 245 cm (145 × 96 in)
Musée du Louvre, Paris

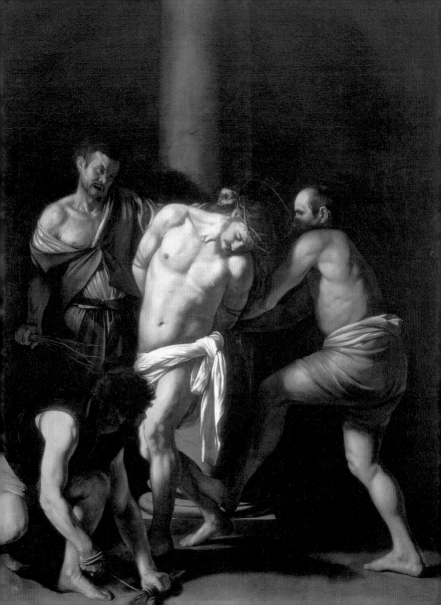

Rebirth

Caravaggio fled south of Rome to the Alban Hills. It's likely that the Colonna family sheltered him there as they had strongholds in Zagarolo and Palestrina, where Caravaggio seems to have hunkered down, hoping for a swift pardon. It did not come. By the autumn of 1606 it was looking so unlikely that Caravaggio made plans for a new life. Presumably with Costanza Colonna's help, he sold a copy of a painting he'd been working on, and used the money to set sail for Naples, where he was reunited with Cecco. The pair probably took up residence in the Colonna's Neapolitan palace.

Naples, at three times the size of Rome, was a cosmopolitan European powerhouse. It was the capital of the busiest trading state in the Mediterranean and growing rapidly. The city was keen to use its new wealth to decorate itself with art, and it greeted Caravaggio more like a gift horse than a fugitive – his fame as a painter, if not as a murderer, preceded him. The Neapolitans fell over themselves to secure his services, and the commissions came pouring in. For the first painting he was paid a reasonable 200 scudi, and double that amount for his second. Less than two months later, no sooner had he finished the second painting than buyers were offering in excess of 2,000 scudi for it.

Meanwhile, in Rome, *The Death of the Virgin* was for sale. The young Flemish painter Peter Paul Rubens was living in Rome at the time and had been deeply impressed by Caravaggio's work. He secured the work for a patron back in Flanders, but had to delay shipment because so many Roman painters were desperate to see it before it left the city.

In Naples, the escaped murderer and celebrated darling was working like a man possessed. Caravaggio's next commission, *The Flagellation of Christ*, was made in about ten weeks. Naples, already in awe, was stunned. Never had they seen such an intense and mesmerizing mix of beauty and cruelty. It was shocking and truthful, and it transformed the course of Neapolitan painting overnight.

Despite his success in the city, Caravaggio decided to journey south to Malta. Where the idea of sailing to this military island outpost ruled by the Knights of Malta came from is a mystery. Even Cecco decided that Malta would be one step too far and stayed in Naples when Caravaggio set sail in June 1607.

Malta

Malta was not an inviting place. Isolated in the Mediterranean between Sicily and the North African coast, which was held by the Turks, the island was an important military frontier between Christendom and the powerful Islamic Ottoman Empire. It was held by the Order of the Knights of Malta, which had its origins in the Crusades and the Crusader kingdoms in the Middle East. The order had survived the collapse of those kingdoms several hundred years earlier and was, by the seventeenth century, an elite and highly effective military order of the Catholic Church. The knights, unsurprisingly, operated a regime of strict military discipline.

Caravaggio's long-term and fabulously audacious plan was to ingratiate himself with the knights and, somehow, to become one himself. Unfortunately, some major hurdles stood in his way. One, he was a convicted felon. Two, even if he'd had the requisite impeccable moral record, he was not a member of the nobility, and this was the only class eligible for knighthood in the order. Caravaggio had one advantage: his skill and renown as a painter. He probably knew how desperate the order was for works of art, too – Caravaggio was not, in fact, the first artist to flee to Malta. He was probably hoping to obtain an 'honourific' knighthood, which was awarded for merit rather than rank. But here he encountered his third hurdle.

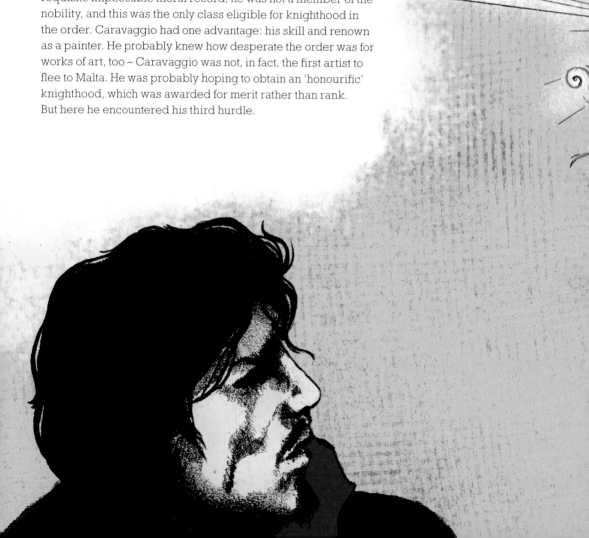

A knight against all odds

The Grand Master of the order, Alof de Wignacourt, had recently announced his decision to terminate the 'honourific' knighthood, the appointment of which he considered subject to corruption and therefore demeaning to the order. He must have come to rue the day he ever let Caravaggio convince him otherwise.

Wignacourt wanted cultural capital for the knights, and Caravaggio provided it. Within months he was painting a portrait of the Grand Master himself, and at the end of 1607, Wignacourt wrote to the pope begging special dispensation for a 'person of virtue and merit' to become a knight, even though he had 'once committed homicide in a brawl'. Miraculously, the request was granted. Caravaggio had defied the odds. To secure the deal he just had to spend one year as a novice, and paint the order's patron saint in an altarpiece for their cathedral.

Caravaggio chose to depict John the Baptist's martyrdom or, more precisely, the moment the executioner (who botched John's beheading) reaches for the knife to sever the martyr's head from his body. Instead of zooming in on the action, Caravaggio drops the life-sized figures into a void of shadow, like children huddled against the dark. The space makes everything still, like a freeze-frame. The very act of looking seems to have frozen them in horror. This is considered by many as the greatest painting of the seventeenth century. It is also the only painting Caravaggio signed: if you look closely at the blood spilling from John's neck, it spells Caravaggio's name.

The painting was a huge success. In July 1608 Caravaggio was given a gold chain and entry to the order. He'd made it. But now that he was a knight, he had to behave like one. That meant no brawling, insults or sexual indiscretions. Worse, novices couldn't leave the island without permission. Caravaggio, who at the beginning of his career had risked starvation for autonomy, was now entirely dependent on the Grand Master's whim.

Weeks later, just two days before his painting was due to be unveiled, a brawl broke out in the house of an organist, Fra Prospero Coppini, and a high-ranking knight was seriously wounded. The incident could not be ignored, and the initiators – who included Caravaggio – were thrown in the knights' impregnable rock of a prison. On the day the order celebrated their patron saint below the new altarpiece, Caravaggio was languishing in jail. It was the ultimate fall from grace.

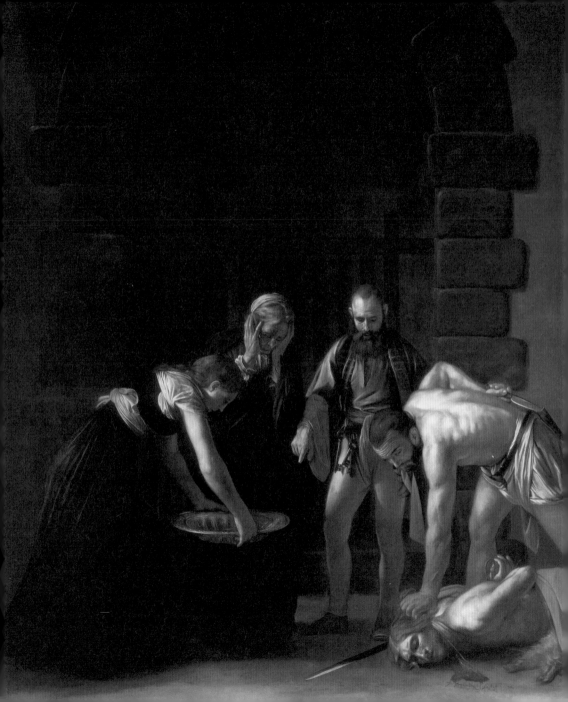

The Beheading of
Saint John the Baptist
Caravaggio, 1608

Oil on canvas
361 × 520 cm (142 × 200 in)
San Giovanni, Valletta

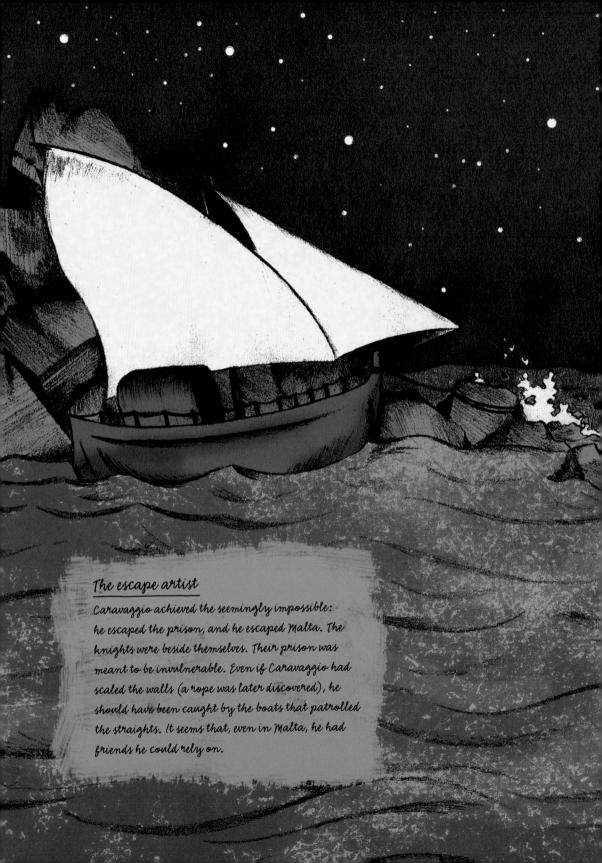

The escape artist

Caravaggio achieved the seemingly impossible: he escaped the prison, and he escaped Malta. The knights were beside themselves. Their prison was meant to be invulnerable. Even if Caravaggio had scaled the walls (a rope was later discovered), he should have been caught by the boats that patrolled the straights. It seems that, even in Malta, he had friends he could rely on.

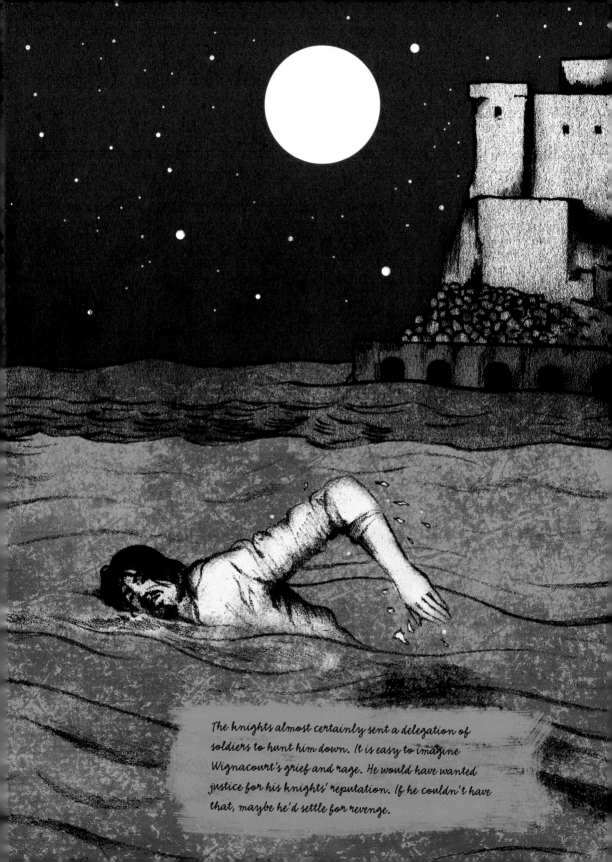

The knights almost certainly sent a delegation of soldiers to hunt him down. It is easy to imagine Wignacourt's grief and rage. He would have wanted justice for his knights' reputation. If he couldn't have that, maybe he'd settle for revenge.

Sicily

The knights couldn't catch Caravaggio – he was already on his way to Sicily – so they dispersed some of their anger by trying him in absentia. Ironically, these trials took place in the cathedral, with the accused's chair placed beneath his painting of Saint John. It was here that the pronouncements were read: Caravaggio was to be 'expelled and thrust forth like a rotten and diseased limb'. He was very much on his own.

Caravaggio was a declared felon in the Papal States, and now he had angered and offended one of the most powerful and influential military and religious organizations of the time – and perhaps the single most powerful network of aristocrats in Europe. Caravaggio fled to his old friend, Mario Minniti, the Sicilian who had modelled for his *Bacchus*, and probably saved him from dying of fever in the studio of the Cesari brothers. Minniti did not let him down.

Minniti had returned from Rome, set up a successful painting workshop in Syracuse, and become a respected figure in the community. He took Caravaggio in and, according to an early eighteenth-century manuscript, secured him commissions by imploring the city's senate to employ 'the best painter in Italy'. Caravaggio fulfilled his commitments, but he was preoccupied and restless. He started to behave in a notably more eccentric manner than usual: eating from a wooden plate, sleeping in his clothes, keeping a sword or dagger close at hand, and securing a guard dog, which he named Crow.

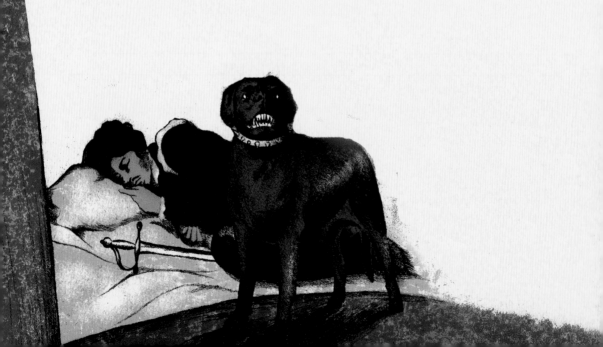

A swaggering nomad

Caravaggio stayed with Minniti for about eight months, completing *The Burial of Saint Lucy*, but he left before the work was unveiled. He headed north to Messina, another vibrant port town, where he hoped to secure more work. Here the eccentricity of his behaviour became even more marked. He seems, unusually, not to have made any friends, and strange tales emerge from this period. In one, Caravaggio, who had apparently started to denounce any religious belief (a very dangerous and almost unthinkable position to maintain), refused holy water in a church because, he claimed, nothing could wash away his sins.

However, he continued to paint. He showed some of his old swagger when he decided to advertise himself as a Knight of Malta. He must have hoped that the story of his disgrace would not catch up with him. Even so, it was a bold and perhaps stupid move since the knights were not restricted to Malta itself, but could be found as advisers and in positions of power throughout Europe. It shows the degree to which, even in such desperate straits, Caravaggio was willing to try his luck.

His confidence may have rested on a tentative plan (in which Costanza Colonna may have played a part) for a papal pardon. The pope's nephew and trusted advisor, Cardinal Scipione Borghese, was an insatiable collector. When Caravaggio fled Rome, Borghese sacrificed his integrity to lay his hands on some unsold Caravaggios. Hearing that Giuseppe Cesari had at least two early works in his collection, Borghese made him a low offer. When Cesari refused to sell, Borghese brought spurious charges against the painter. Then, whilst Cesari was detained in prison, Borghese appropriated his entire collection; the two Caravaggios remain to this day in the Borghese collection. The Colonna certainly had connections with the Borghese, so perhaps Costanza and Caravaggio hoped Scipione's admiration and the promise of more paintings would help the situation – if anyone could get a pardon from the pope, it would be his nephew.

Meanwhile, in Messina, patrons held bidding wars over Caravaggio's services. One family, the Lazzaretti, agreed to pay 1,000 scudi for an altarpiece of *The Raising of Lazarus* – a far cry from the 8 scudi Del Monte paid him back in 1595. Even compared to the more prestigious commissions in Rome, his work was now commanding extraordinary figures.

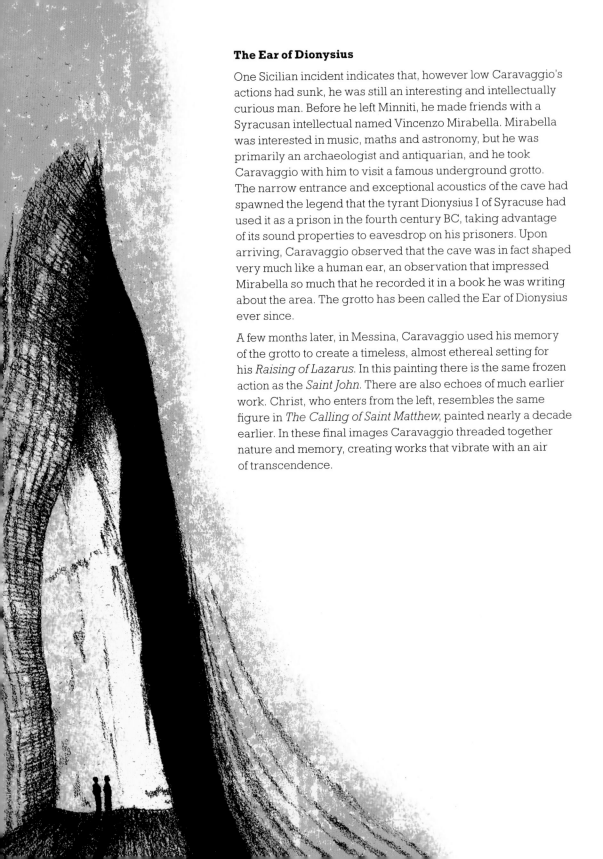

The Ear of Dionysius

One Sicilian incident indicates that, however low Caravaggio's actions had sunk, he was still an interesting and intellectually curious man. Before he left Minniti, he made friends with a Syracusan intellectual named Vincenzo Mirabella. Mirabella was interested in music, maths and astronomy, but he was primarily an archaeologist and antiquarian, and he took Caravaggio with him to visit a famous underground grotto. The narrow entrance and exceptional acoustics of the cave had spawned the legend that the tyrant Dionysius I of Syracuse had used it as a prison in the fourth century BC, taking advantage of its sound properties to eavesdrop on his prisoners. Upon arriving, Caravaggio observed that the cave was in fact shaped very much like a human ear, an observation that impressed Mirabella so much that he recorded it in a book he was writing about the area. The grotto has been called the Ear of Dionysius ever since.

A few months later, in Messina, Caravaggio used his memory of the grotto to create a timeless, almost ethereal setting for his *Raising of Lazarus*. In this painting there is the same frozen action as the *Saint John*. There are also echoes of much earlier work. Christ, who enters from the left, resembles the same figure in *The Calling of Saint Matthew*, painted nearly a decade earlier. In these final images Caravaggio threaded together nature and memory, creating works that vibrate with an air of transcendence.

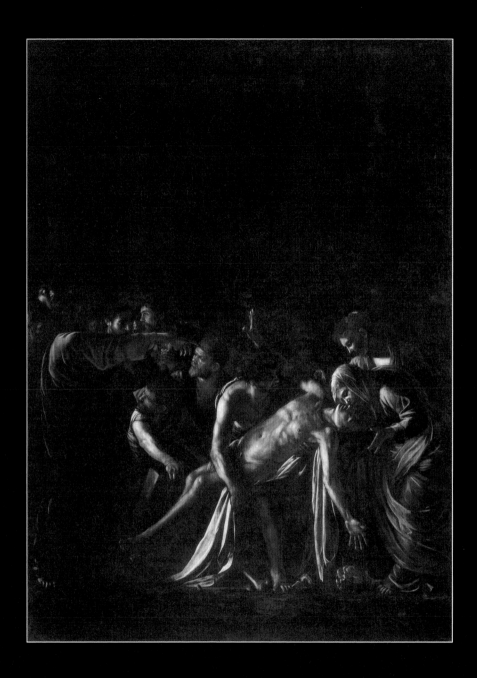

The Raising of Lazarus
Caravaggio, c. 1609

Oil on canvas
380 × 275 cm (150 × 108 in)
Museo Regionale, Messina

A fatal mistake

By the autumn of 1609 Costanza Colonna had once again waved a magic wand to dispel Caravaggio's troubles. She was working through Scipione Borghese to obtain a pardon, and she seems to have obtained an unofficial one with Wignacourt. Her own son, Fabrizio, a black sheep, had been sent to Malta in 1602 as a 'privileged exile' from the mainland and had risen in the order to sit on the knights' Venerable Council. Caravaggio seemed optimistic – he moved back to the mainland, to Costanza's palace in Naples, and began to show his face around the city. His confidence was not merited.

News of the painter's presence spread fast. Perhaps he thought he'd been forgiven for his past misdeeds. Perhaps he thought Costanza's power would protect him. Perhaps he was just tired of hiding. Either way, in mid-October 1609 he decided to go to the Osteria del Cerriglio, a bawdy pub popular with artists and poets. When he left, an attacker or attackers ambushed him in much the same way as he'd ambushed the young artist Spampa years before. This time, however, the attack was successful. Caravaggio was disfigured with a *sfregio*, his face slashed in a calculated sign of revenge. It was a vicious attack: his health collapsed and he was left fighting for his life.

Theories as to the identity of his attacker are inconclusive. It's unlikely that Wignacourt would personally have ordered it, but it could have been the Knight of the Order that Caravaggio wounded, and presumably embarrassed, during the brawl in Malta back in 1608. It could even, of course, have been one of the Tomassoni gang, come to seek their vengeance. Considering Caravaggio's personality, it could simply have been someone he picked a fight with that day on the streets of Naples. We'll never know. What we do know is that it spelt, more or less, the end for this great painter.

From bad to worse

Caravaggio struggled towards health over the following months. He must have been cared for at Costanza's palace, and that's probably where he painted his final works. It is also where he put into action his last desperate scheme to return to Rome after three years on the run. There have been varied and wild conjectures over the nature of this plan, but the catalyst was probably that Costanza Colonna and Scipione Borghese had somehow managed to obtain a pardon from the pope.

On 9 July 1610, Caravaggio set out for Rome. He travelled in a felucca (a traditional wooden sailing boat), the *Santa Maria di Porto Salvo*, whose captain he knew and trusted, with three precious paintings stored in the hold. These were almost certainly the bargaining chips of the pardon, bound for Scipione Borghese. Caravaggio's work was, once again, not only his fortune but his saving grace. Unfortunately, a few days later, everything began to go horribly wrong.

When the boat made a routine stop at the fortified port of Palo, there was an uproar of some sort and Caravaggio was detained. The soldiers who manned the garrison were either unaware of the promised papal pardon, or Caravaggio, in his habitually belligerent manner, initiated some kind of fracas. Either way, the soldiers arrested him and, to escape the fray, the captain of the boat put out to sea. The soldiers delayed Caravaggio for long enough that, by the time he eventually cajoled or bribed his way out of jail, the boat, with his precious paintings – the only means of securing his freedom – was gone.

Still weak from the Neapolitan attack, Caravaggio decided that his only option was to catch the boat. Baglione asserted in his biography that the deranged artist desperately chased the boat up the coast. However, it is highly unlikely that Caravaggio ever set out on foot – he was in poor health and had about 50 kilometres (30 miles) to cover in about two days. Most likely he set off under the mid-July sun on horseback, relying on the post horses that ran between military outposts. He headed straight for Porto Ercole, another fortified town north of Rome, which he must have known was the boat's final destination. The assumption would have been that without him onboard, the captain would not delay with an unnecessary stop at Rome. It was crucial that he caught the boat with his paintings before it headed south again, back to Naples.

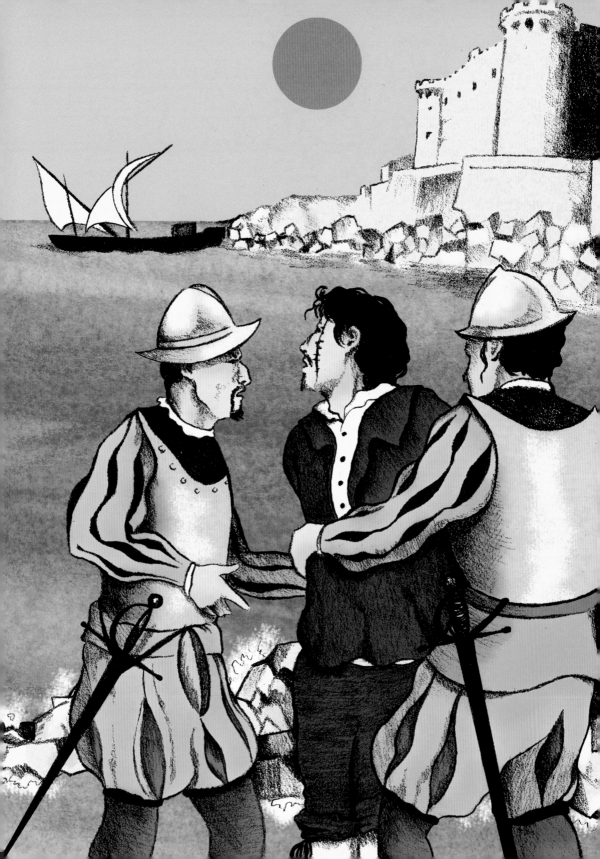

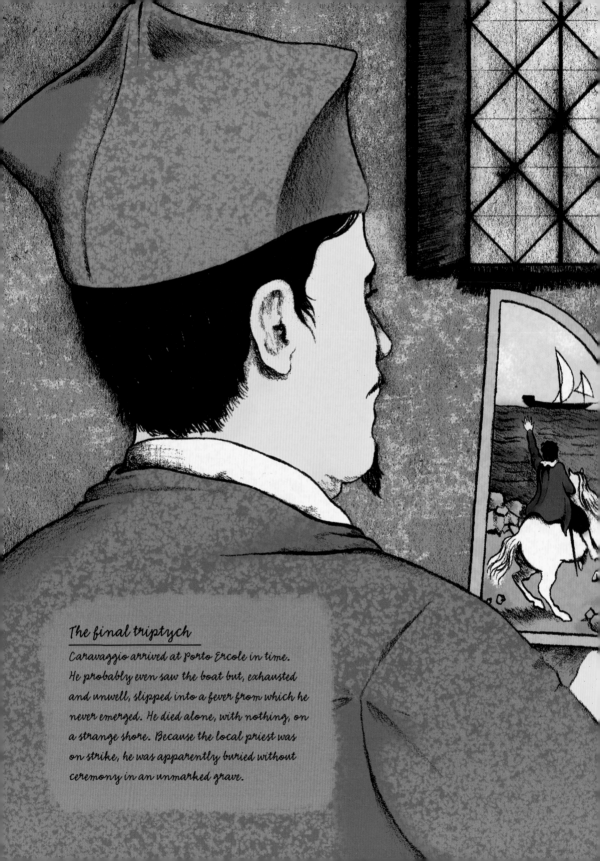

The final triptych

Caravaggio arrived at Porto Ercole in time.
He probably even saw the boat but, exhausted
and unwell, slipped into a fever from which he
never emerged. He died alone, with nothing, on
a strange shore. Because the local priest was
on strike, he was apparently buried without
ceremony in an unmarked grave.

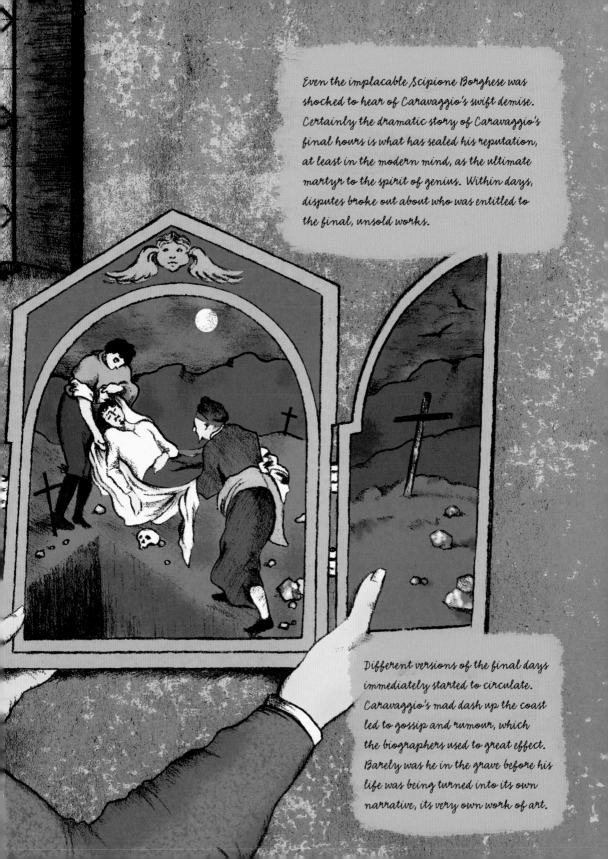

Even the implacable Scipione Borghese was shocked to hear of Caravaggio's swift demise. Certainly the dramatic story of Caravaggio's final hours is what has sealed his reputation, at least in the modern mind, as the ultimate martyr to the spirit of genius. Within days, disputes broke out about who was entitled to the final, unsold works.

Different versions of the final days immediately started to circulate. Caravaggio's mad dash up the coast led to gossip and rumour, which the biographers used to great effect. Barely was he in the grave before his life was being turned into its own narrative, its very own work of art.

A dramatic legacy

In Caravaggio's final self-portrait, his dark, bearded face
appears in a haunting interpretation as the beheaded Goliath.
The painting has often mistakenly been dated to 1610 – the
end of his life – but was actually made at the beginning of his
exile, in 1606 or 1607. It was one of the works that ended up
with Scipione Borghese, possibly while Caravaggio was in
Messina, and would have been part of his plea for a pardon.
Into it Caravaggio has poured all of human experience:
violence, compassion, innocence, grief, cruelty and loss.
David looks down with tenderness but also disgust at the
stricken Goliath, whose neck gushes blood. Goliath's eyes
bear the same terrifying consciousness of death and pain as
Medusa's had done years before. But unlike the earlier work,
everything here – even the emotion – seems stripped down
to its bare essentials. It is hard not to see the two characters,
set in such dramatic light and shadow, as representing some
kind of resolution in the battle between the two aspects of
Caravaggio's character.

Many recent critics have dubbed Caravaggio the first 'modern'
artist. And it is true that his art broke the centuries-old tradition
of artists transforming reality into an idealized version of itself.
While often embracing the dramatic, Caravaggio's work refused
to shy away from emotion, ugliness, poverty and desperation.
For this reason, in death as in life, he continued to divide
opinion. Later in the century the great French academician
Nicolas Poussin declared that Caravaggio was 'sent into the
world to destroy painting'; he was possibly referring to the
scores of Caravaggio's imitators who sprang up across Europe,
from Rome to Paris to Amsterdam. There were so many that
they were dubbed the 'Caravaggisti', and they celebrated his
dramatic immediacy, his lighting and his grittiness. Echoes
of his influence appear in the work of a remarkable number
of great artists from the following generation, too: Rubens,
Rembrandt, Velázquez and even Vermeer. And the roll call of
great artists inspired by him has never stopped: from David
and Géricault at the birth of Romanticism, to the film-makers
Pier Paolo Pasolini and Martin Scorsese. Caravaggio remains
unexpectedly contemporary – a timeless mirror.

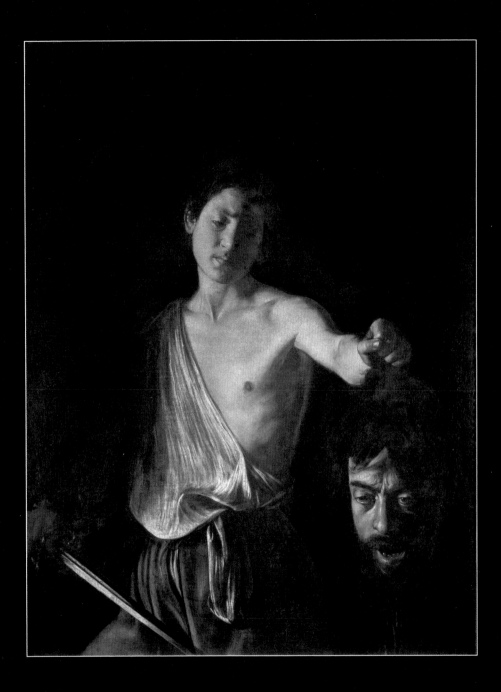

David with the Head of Goliath

Caravaggio, c. 1606–7

Oil on canvas
125 × 101 cm (49 × 40 in)
Galleria Borghese, Rome

Acknowledgements

I would like to thank Donald Dinwiddie and Iker Spozio for making this book what it is. Further thanks to Marina Hamilton-Baillie, Nick Ross of Art History Abroad, and D. W. Wilson.

Bibliography

Gilbert, Creighton E. *Caravaggio and His Two Cardinals*. University Park: Pennsylvania State University Press, 1995.

de Giorgio, Cynthia, and Keith Sciberras. *Caravaggio and Paintings of Realism in Malta*. Valletta: Midsea Books, 2007.

Graham-Dixon, Andrew. *Caravaggio: A Life Sacred and Profane*. London: Penguin, 2010.

Langdon, Helen. *Caravaggio's Cardsharps: Trickery and Illusion*. New Haven: Yale University Press, 2012.

Moffitt, John F. *Caravaggio in Context: Learned Naturalism and Renaissance Humanism*. Jefferson: McFarland and Co., 2004.

Sciberras, Keith, and David M. Stone. *Caravaggio: Art, Knighthood, and Malta*. Valletta: Midsea Books, 2006.

Spinosa, Nicola (ed.). *Caravaggio: The Final Years*. Naples: Electra Napoli, 2005.

Strinati, Claudio (ed.). *Caravaggio*. Milan: Skira, 2010.

Varriano, John. *Caravaggio: The Art of Realism*. University Park: Pennsylvania State University Press, 2006.

Vodret, Rossella (ed.). *Caravaggio's Rome: 1600–1630*. Milan: Skira, 2012.

Back cover quote: Robert Hughes, 'Art: Master of the Gesture. At the Metropolitan, Caravaggio's turbulent genius', *Time*, March 11, 1985.

Annabel Howard

Annabel Howard is the author of *This is Kandinsky* (2015) and *Art Visionaries* (with Mark Getlein, 2016). She has degrees in art history and biographical writing, and has taught and lectured in museums throughout the United Kingdom and Italy. She has written articles for magazines including *Glass*, the *White Review* and the *Spectator*.

Iker Spozio

Iker Spozio is an illustrator, engraver and painter who lives and works in Spain. His work has been featured in international publications such as *Le Monde* and *Il Corriere della Sera*, but he mostly works in the music field, creating artwork for record labels worldwide, including Deutsche Grammophon, Thrill Jockey and FatCat.

Picture credits

4 akg-images/Rabatti – Domingie; **10** Photo Scala, Florence – courtesy of the Ministero Beni e Att. Culturali; **15** © Quattrone, Florence; **18** akg-images / Erich Lessing; **23** Photo Scala, Florence; **24** De Agostini Picture Library / © Veneranda Biblioteca Ambrosiana – Milano/Bridgeman Images; **30** akg-images / Andrea Jemolo; **33** Photo Scala, Florence – courtesy of the Ministero Beni e Att. Culturali; **36** © Quattrone, Florence; **37** © Vincenzo Pirozzi, Rome fotopirozzi@inwind.it; **38** Alinari Archive, Florence; **40** Vatican Museums; **41** © Quattrone, Florence; **42** Raffaello Bencini / Alinari Archives, Florence; **45, 46, 47** © Vincenzo Pirozzi, Rome fotopirozzi@inwind.it; **49** Photo Scala, Florence / bpk, Bildagentur für Kunst, Kultur und Geschichte, Berlin; **51** 2007 Alessandro Vasari, Rome – Reproduced with the permission of Ministero per i Beni e le Attività Culturali / Alinari Archive, Florence; **53** © Araldo De Luca, Rome; **59** akg-images / Pietro Baguzzi; **60** Photo Scala, Florence / Fondo Edifici di Culto – Min. dell'Interno; **64** Photo Scala, Florence; **71** Photo Scala, Florence – courtesy of the Ministero Beni e Att. Culturali; **79** © Vincenzo Pirozzi, Rome fotopirozzi@inwind.it